SECRETS TO DRAWING REALISTIC CHILDREN

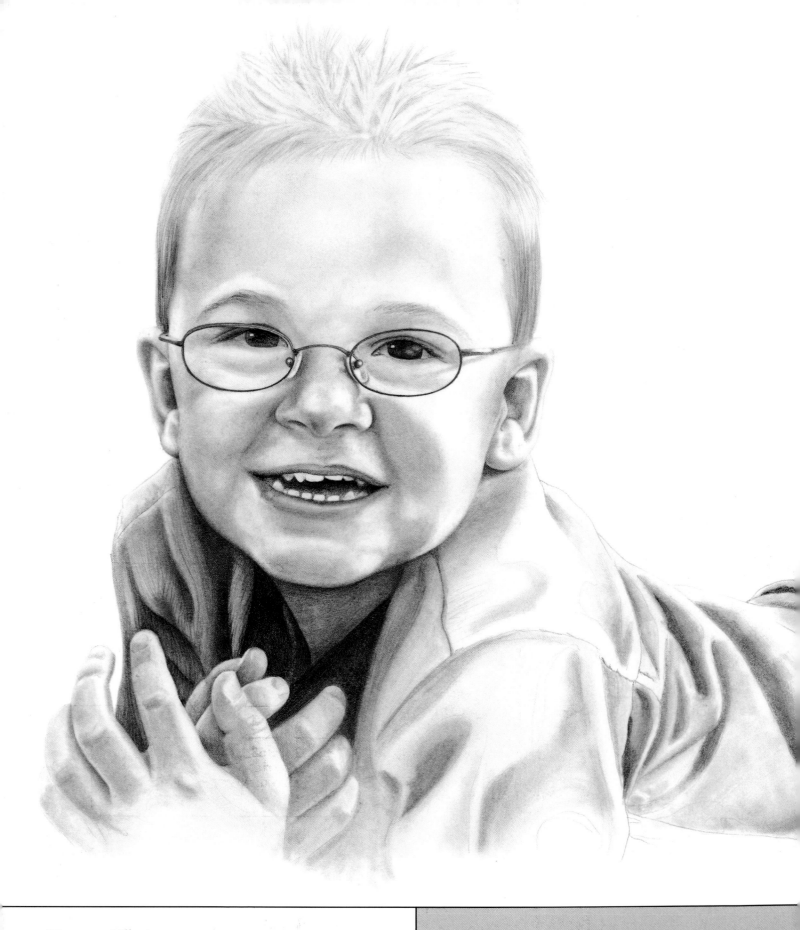

WILLIAM MAX IRWIN
Graphite pencil on smooth bristol board
12" × 14½" (30cm × 37cm)

secrets to

DRAWING
REALISTIC
CHILDREN

CARRIE STUART PARKS
& RICK PARKS

NORTH LIGHT BOOKS
CINCINNATI, OHIO
www.artistsnetwork.com

Other fine North Light titles are available at your local fine art retailer, bookstore or online supplier or visit our website at www.fwpublications.com.

12 11 10 09 08 5 4 3 2 1

DISTRIBUTED IN CANADA BY FRASER DIRECT
100 Armstrong Avenue
Georgetown, ON, Canada L7G 5S4
Tel: (905) 877-4411

DISTRIBUTED IN THE U.K. AND EUROPE BY DAVID & CHARLES
Brunel House, Newton Abbot, Devon, TQ12 4PU, England
Tel: (+44) 1626 323200, Fax: (+44) 1626 323319
Email: postmaster@davidandcharles.co.uk

DISTRIBUTED IN AUSTRALIA BY CAPRICORN LINK
P.O. Box 704, S. Windsor NSW, 2756 Australia
Tel: (02) 4577-3555

Library of Congress Cataloging in Publication Data
Parks, Carrie.
 Secrets to drawing realistic children / Carrie Stuart Parks and Rick Parks.
 p. cm.
 Includes index.
 ISBN-13: 978-1-58180-963-3 (pbk. : alk. paper)
 1. Children--Portraits. 2. Face in art. 3. Portrait drawing--Technique.
I. Parks, Rick. II. Title.
 NC773.P368 2008
 743.4'5--dc22 2007027329

Edited by **Mona Michael** and **Megan Milstead**
Production edited by **Sarah Laichas**
Interior designed by **Jennifer Hoffman**
Cover designed by **Kelly Piller**
Production coordinated by **Matt Wagner**

ABOUT THE AUTHORS

Rick and Carrie Parks blend their love and friendship with their Christian faith, home and art careers. They team-teach forensic art classes throughout the nation, winning national awards for their outstanding instruction and for inspiring others to achieve artistic excellence. They are both forensic artists and have worked on major national and international cases. Their forensic art has appeared on multiple television shows, including *America's Most Wanted* and *20/20*.

In addition to teaching, Rick and Carrie create fine art in pencil, watercolor, pastel pencils and stone carvings. Carrie is a signature member of the Idaho Watercolor Society and has won numerous awards for her paintings.

To find out more about the Parks or to find a class near you, check out their website at www.stuartparks.com. Contact Rick at rick@stuartparks.com or Carrie at carrie@stuartparks.com.

Metric Conversion Chart

To convert	to	Multiply by
Inches	Centimeters	2.54
Centimeters	Inches	0.4
Feet	Centimeters	30.5
Centimeters	Feet	0.03
Yards	Meters	0.9
Meters	Yards	1.1

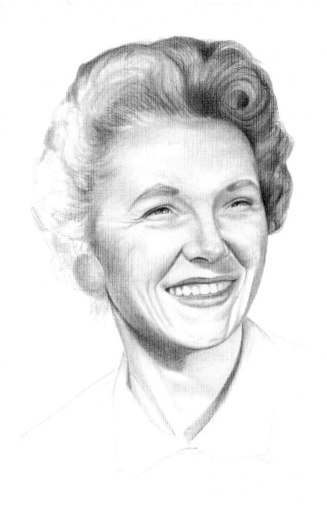

DEDICATED TO
MARY EVELYN McCANDLESS STUART

Mom was born on October 18, 1930, in Wallace, Idaho, to Ida Mae and Merle G. McCandless. She had an older brother, Bob. She married Ned Stuart on January 1, 1950. They had three children: Steven, Scott and Carrie Ann. Evelyn was a teacher and guidance counselor in the Kellogg, Idaho, school system. She raised show dogs. She was five feet seven inches tall with a slender build, hazel eyes and (usually) blonde hair.

Those are the dry facts of a truly exceptional woman who finally lost a long and painful battle with emphysema in the spring of 2005. She passed away in her sleep, at home in her bed next to a window overlooking her beloved Great Pyrenees dogs.

Mom was too ill to know of my battle with breast cancer, nor did she live to see the publication of our previous book on drawing, but I know she would have been so very proud of my victory over cancer and my literary accomplishments.

She was a great mom, my inspiration and my hero. I miss her every day.

ACKNOWLEDGMENTS

I just know I'll forget someone critical to my writing, art or life in the acknowledgments, so, if I do, I'll start off by saying I'm sorry and thank you! This book wouldn't be a reality without the wonderful children featured in these pages. I am so grateful to the parents who took time to send us photos or drive their children over so that we could photograph them.

Natalie Sweet, I love you! You and Al opened your home to us and rounded up your friends and family so that we could get the references we needed.

Greg Bean, as always, shared his wonderful art with us. I'm not sure we could do a book without at least calling him for a contribution. Janel Karrle, thank you for thinking of us and orchestrating the tea party photos, so beautifully snapped by Charlene Chavez. Philippe Faraut, you're a gifted sculptor. Thank you for your class, your use of plaster models for our book, and your talent (www.philippefaraut.com). Marlene Hirose, the San Jose, California artist we met at Philippe's class, thank you for your sketches of the kindergarten class. Nadeoui Eden, thank you for sharing more than your art with us.

To the brave and hardworking folks at North Light Books, thank you for entrusting me with this latest book: Mona Michael, Vanessa Lyman, Sarah Laichas and Pam Wissman. Thankyouthankyouthankyouthankyou.

A belated but deeply grateful thank-you to the great people at the North Idaho Cancer Center, in particular Dr. Haluk Tezkan and Patricia. Also thanks to my surgeons Dr. Philip Kladar and Dr. Robert Cooper. My body is whole, and I'm in remission from breast cancer thanks to you.

Finally, blessings and much love to our life inspirations, Frank and Barb Peretti, and the center of our lives, our Lord and Savior, Jesus Christ.

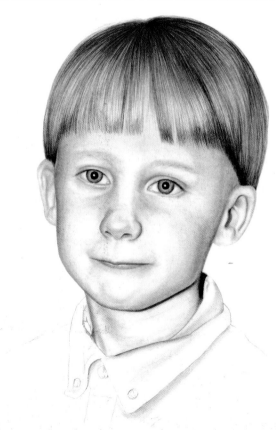

TABLE OF CONTENTS

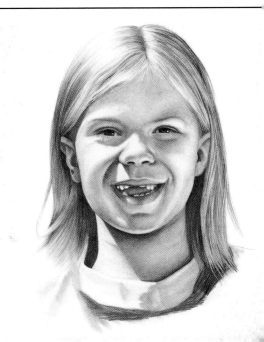

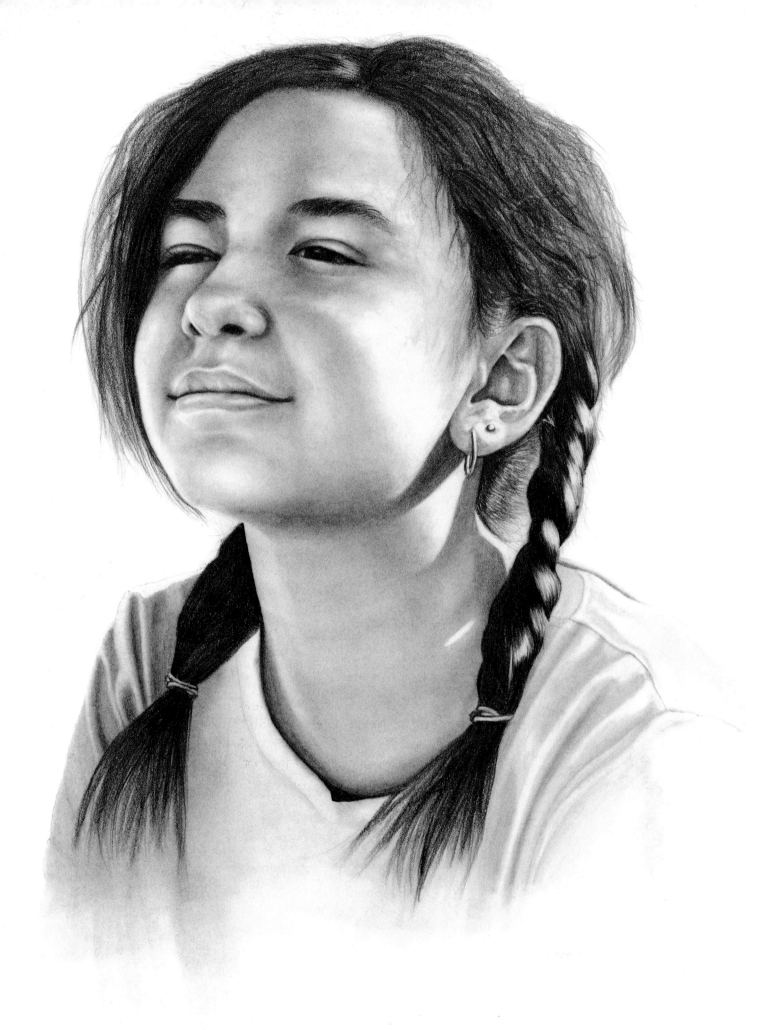

INTRODUCTION

Smile! Click. You've photographed your precious tyke. Now it's time to turn him or her into a work of art. I'm hopeful this book will be just what you need.

This is our third book on drawing, and probably our most anticipated. Almost everyone wants to learn how to draw children, and not just any child, *their* child (or grandchild). I started out on this journey of writing and illustrating by photographing children, and immediately came across amazing challenges. Babies wouldn't open their eyes. Teenagers wanted to wear sunglasses and hide their braces. Two- and three-year-olds had to be lassoed to stay still for longer than five seconds. Parents, however, were delighted to think their child might appear in this book. Thank you, parents!

In this book we've covered many drawing examples and techniques specific to children. For even more information on drawing faces, you'll want to add my book, *Secrets to Drawing Realistic Faces* (published by North Light Books) to your library. I'd feel better, you'll do better and my publisher will be very happy.

Now, sharpen those pencils, get out your paper and prepare to create a masterpiece!

CORTNEY LINDSEY
Graphite pencil on smooth bristol board
16½" × 14" (42cm × 36cm)

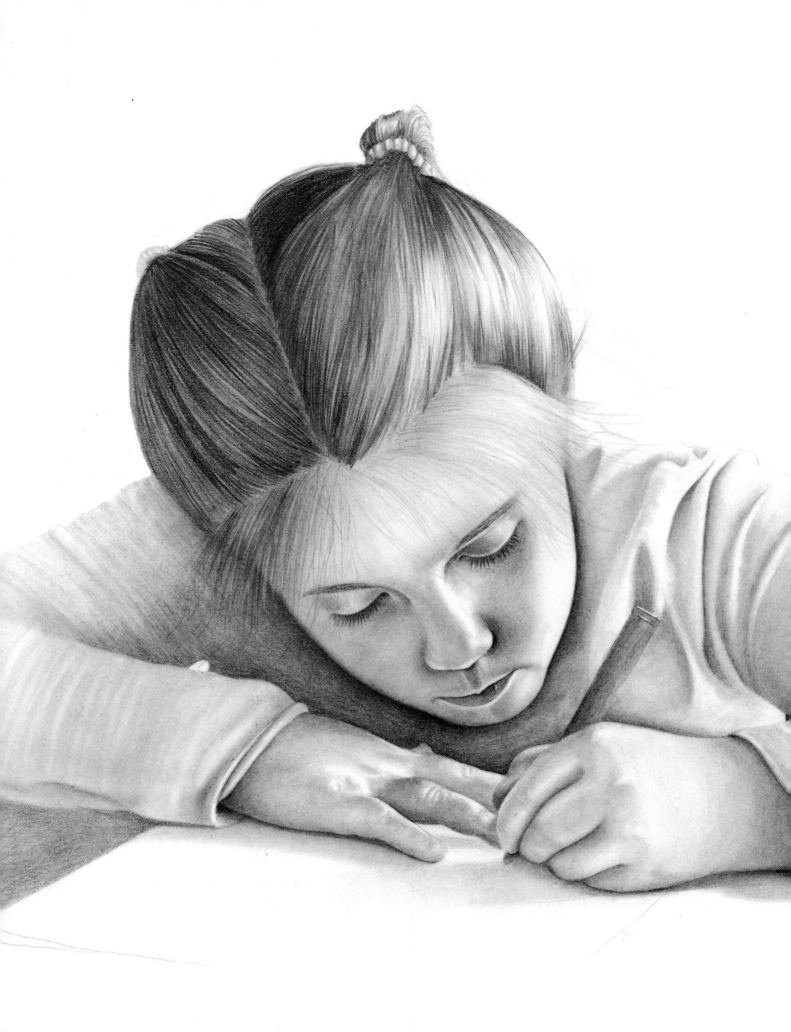

Art Toys

Art Toys for All Ages

Children love to draw and experiment with various art tools (occasionally on your pristine walls). You should aspire to the same attitude toward drawing—a fearless desire to try new techniques, tools and subjects.

After testing a variety of pencils and papers, I've found the best combination for this particular result is graphite pencils, paper stumps and smooth bristol board.

SHILO STUART
Graphite pencil on smooth bristol board
12" × 14½" (30cm × 37cm)

Some people purchase shoes. Some buy cars. Some, like my husband—for reasons only known to him—collect baseball hats. Artists, or artists-in-training, need art toys. You can never have enough art supplies. Sure, you could probably get by with a yellow No. 2 pencil and the back of a paper sack, but would you want to? You need stuff. And you need stuff to put the stuff in. Plastic containers, little drawers, wicker boxes, fishing tackle boxes, art containers. Owning art stuff is required of all artists.

Even though drawing tools are probably some of the least expensive art supplies, it does make a difference when you use the right materials. I've had many students struggle to make something work when the entire problem could have been avoided with the right pencil and paper. As you grow more comfortable drawing, you'll try out different supplies. Now, I'm ordering you to go shopping! (Don't you just love this book already?)

Pssssst!
The secret to drawing? It starts with having the right STUFF.

Pencils

Let's look at pencils. Your cheerful yellow No. 2 pencil usually contains an HB lead. It would perform just fine as a drawing pencil, but ask yourself, is it really cool? No, buying a sparkly version doesn't make it better. You need stuff, remember? There are quite a few pencil choices to consider:

- **Mechanical pencils** come in a variety of colors and easily found in most art stores. They usually consist of a plastic holder and a fine HB lead that advances by clicking on an end or side button. They create consistent lines of equal width.

- **Lead holders** are available in the drafting section of most office supply stores and come with an HB lead. Various grades of 2mm lead can be purchased and easily placed into the holder. The main difference between lead holders and mechanical pencils is that a mechanical pencil cannot be sharpened. Unlike a lead holder, its tip is very small and will break if you apply too much pressure.

- **Graphite and charcoal pencils** differ in several ways. Graphite pencils, often called lead pencils, consist of ground graphite mixed with clay, placed in a wooden holder. They are available in many grades, although there is a slight difference in the darkness among brands. They often create a shine in the drawing as light hits the surface. Charcoal pencils have more "drag" when you use them, may be more difficult to erase, and create a different appearance in your drawing. They often come in only three or four degrees of darkness.

- **Carbon pencils** combine the darkness of charcoal with the smoothness of graphite and may be combined with either graphite or charcoal in a single drawing.

- **Ebony pencils** are very dark, smooth graphite pencils. Many artists love these pencils, but they may limit your ability to build subtle tones.

- **Wash pencils** are water soluble graphite pencils. They may be applied to wet or dry watercolor paper. You can also apply a clear water wash for different effects.

Pencil Grades

There are about twenty grades of graphite available, ranging from the lightest and hardest at one end of the scale (9H), to the softest and darkest at the other end (9B). The HB lead in your yellow pencil is medium-grade, workable lead (or, technically, graphite). Your choice of pencil is determined by your drawing style and paper choice.

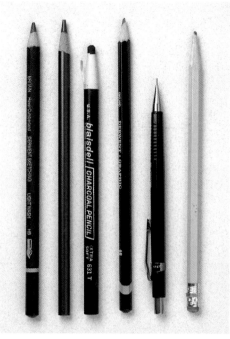

Different Pencils, Different Effects
The standard No. 2 pencil works just fine for drawing, but other grades of lead will be needed for some of the effects found in this book. From left to right are wash pencils, ebony, charcoal, graphite, mechanical and basic yellow.

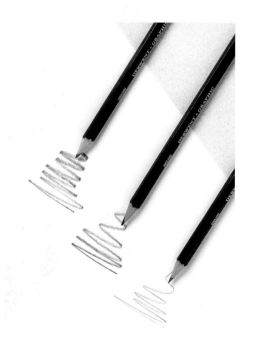

Pencil Grades
Hard pencil grades make lighter lines, while softer grades make darker lines.

Psssssst!

We will be using only four types of graphite in this book: 2H, HB, 4B and 6B. Purchase several 6B pencils; they wear out fast.

Fancy Stuff

Drawing sets are very nice and make wonderful gifts, but they're not necessary for drawing. If you purchase a kit, be sure it looks like you'll try most of its supplies, because some contain pencils you may never use.

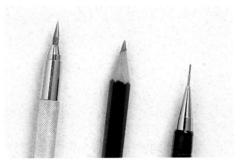

Get the Point

Compare the point on a lead holder with the point on a regular drawing pencil and a mechanical pencil.

HOW TO USE LEAD HOLDERS

Lead holders are our choice for drawing because they form a sharp point.

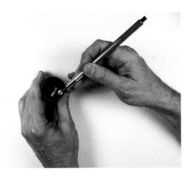

❶ Expose the Correct Amount of Lead

The top of the lead pointer has two small holes. Release some of the lead from the holder and place it into one of the holes.

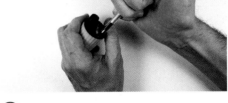

❷ Correct Length

The size of the hole is the exact amount of lead you will need to sharpen. Slide the extra lead back into your pencil until the metal tip rests on the sharpener.

❹ Sharpen

Now place the lead holder into the larger opening. Jiggle it a bit so it is correctly positioned. The entire top will rotate in a circle, sharpening on all sides. Don't worry if you don't do well the first time. This takes a bit of practice.

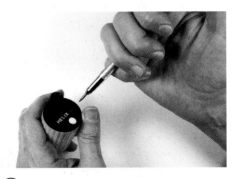

❸ Ready to Go

You now have the exact amount of graphite exposed.

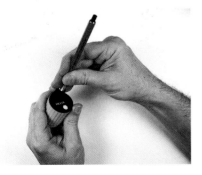

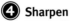

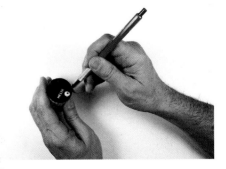

❺ Clean Up

There's a small white area on your lead pointer filled with soft-rolled paper. Push your sharpened tip into this paper to clean off the excess graphite. You're ready to draw!

Erasers

Most people have the idea that erasers are used only for boo-boos. Make a mark, erase it. Make another mark, erase again. Erasers are far more useful than that. They can lighten areas, create textures and add a variety of different effects to your drawing.

Unlike pencils, erasers are not lined up and clearly labeled for the shopper's convenience, so you'll need to investigate your options before making a purchase. There is a wide selection of erasers available, each varying in hardness (or firmness) and messiness (how much eraser residue is left behind). The upside, though, is that with so many options you're guaranteed to find an eraser that suits your needs.

Types of Erasers

- **Pink Pearl** is a common eraser with attitude. It gets into your drawing and really tears up the graphite. But be cautious: The same aggression this eraser applies to graphite is also applied to your paper. There's a possibility that your paper will be roughened up as well.
- **Kneaded erasers** made from rubber are soft and pliable. You can wad them into a point to lift graphite out of tight places or use them to lighten an area that's too dark by pushing them straight down on the art, then lifting. Clean them by stretching them back on themselves.
- **White plastic** or vinyl erasers are your best choice for general cleanup. They are nonabrasive, tend to be gentle on your work and leave behind no residue.
- **Gum erasers** are useful but terribly messy. They shed worse than a collie in spring.

- **Electric erasers** are great, especially the smaller, battery-operated versions. See "Going Electric" for more detailed descriptions.

I use the white plastic and kneaded erasers the most. I like the way the white plastic eraser handles the paper—gently yet efficiently. The kneaded eraser lifts out the graphite without destroying the underlying pencil lines.

Going Electric

Remember when I said drawing supplies are inexpensive compared to other mediums? Think about the money you've saved!

Because you have all that extra money, you're now going to spend it on your first big purchase: a portable electric eraser.

There are several brands of portable electric erasers on the market, but I find the Sakura brand works best. Some brands spin too fast, grinding into the paper and leaving rough spots. Some brands stop spinning as soon as you touch the paper. The Sakura eraser has the right spin to erase, can be sharpened to a fine point by using a sanding block and is easy to hold.

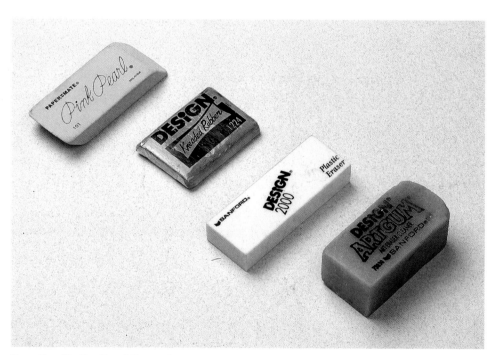

Rounding Up the Usual Suspects
From left to right are the Pink Pearl, kneaded, white plastic and gum erasers.

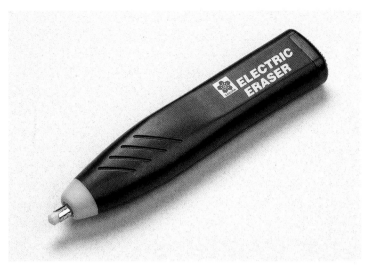

My Favorite Electric Eraser
I like the Sakura portable electric because it handles like a pencil and erases cleanly without tearing up the paper.

My Favorite Kneaded Erasers
Colored kneaded erasers by Faber–Castell don't stain your work and come in red, yellow and blue. Blue's my favorite; it matches my eyes.

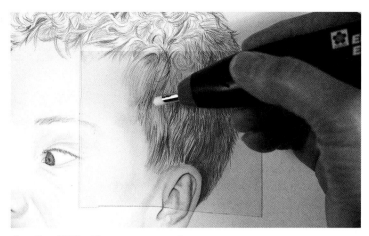

Creating White Lines
You can't draw white lines on white paper, but you can lift them out of your shading using the electric eraser. Practice creating the effect of white hairs, eyebrows or highlights in the eyes and hair.

Sharpening Your Electric Eraser Tip
In order to "draw with white," that is, make fine lines with your eraser, you'll need to sharpen the tip. An old piece of sandpaper works fine, as does a sanding block created for artists. Turn on your eraser and angle it so that the spinning eraser forms a sharp point.

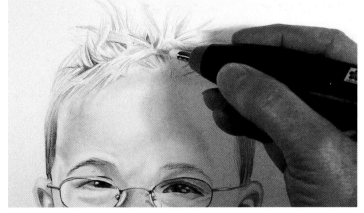

Drawing White Lines
An electric eraser with a sharpened tip allows you to accurately draw white lines through your shaded areas.

Other Absolutely Necessary Toys

I once handed my five-year-old nephew a toy catalog and asked him what he wanted for Christmas. He opened the book and studied the first page intently, then said, "everything on this page." He looked at the facing page, waved his hand over it and declared, "everything on this page, too." He went through the entire book like that, asking for everything but the dolls.

No, you don't need to buy everything on every page of the art supply catalog, but you do need to add a few more items to your shopping cart.

Ruler

We'll use a ruler for a variety of different projects, and the best one by far is the C-Thru plastic ruler. The C-Thru ruler has a centering section so you can find the middle of anything. The interior lines make it easy to create 90-degree angles (trust me, we'll need that). I prefer the 12" × 2" (30cm × 5cm) version.

Circle Template

Certain things are a given. Chocolates have calories. You'll run into the most people you know at the grocery store when you look your worst. And drawing perfectly round circles is impossible without help. The next item for your drawing kit is a circle template. You can find it in most drafting areas of office supply stores as well as general art stores. You will absolutely need it. Find one with a variety of small holes.

Erasing Shields

Erasing shields are inexpensive tools made of thin metal that you erase over top of to create different effects. You can create a custom template by cutting through a piece of acetate with a hobby knife. The best acetate to use is clear plastic report covers.

Blending Tools

Many artists use their pencils to create shading, smudging and blending without resorting to some form of a blending device. It can make for a beautiful drawing, but requires skillful handling of the pencil. You may also take the other route and create nice shading with tools.

A short list of blending tools includes a paper stump, tortillion, chamois and a cosmetic sponge. Don't even *think* of using your finger because the oils will transfer to your paper. The paper stump is used on its side; the tortillion is used on its tip.

Proportional Divider

A handy (albeit expensive) tool is the proportional divider. It allows you to measure between your drawing and your art. There are several art suppliers on the Internet that carry this item. I'll demonstrate how to use one in a later chapter (see "Using a Proportional Divider" on page 58).

Horsehair Brush

My final toy is a horsehair brush to remove the erasing dandruff. A bird feather, soft-complexion brush or soft paint brush also work well. You don't want to use your hand because that will smear the drawing, and if you try to blow the debris off, there's a good chance that you might include some spit. Take it from me, spit doesn't add to your drawing.

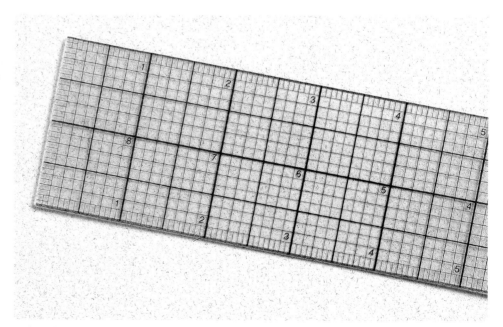

Ruler With a Grid
I use the C-Thru plastic ruler for precise measurement.

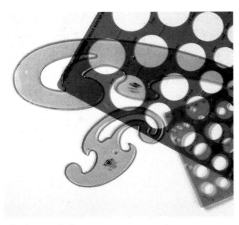

Circles and Curves
Circle templates and French curves allow you to draw perfect circles and curved edges.

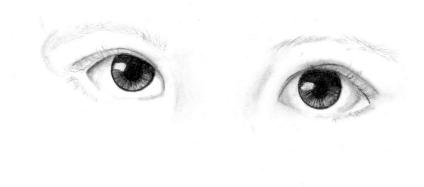

Round Is Beautiful
The only way you'll achieve eyes this nice is with a circle template.

Erasing Shields
I use the erasing shield to clean up edges when I blend outside of the face.

Creating a Custom Template
By cutting through a template, you can shade a particular shape that may otherwise be difficult to do.

Subtracting Using a Template
That same template allows you to customize the area you want to erase.

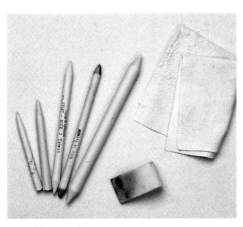

Blending Tools
From left to right are tortillions, paper stump, chamois and a cosmetic sponge.

Art Brush
Find a soft brush to clean up your debris, and make your drawing easier.

Proportional Divider
Use this handy tool to measure between your drawing and art.

Paper

Drawing paper is sold as individual sheets, in bound pads, in various shades of white to cream, in different weights (thickness), acid content (from newsprint to acid-free) and with finishes ranging from very smooth to quite textured. There isn't a right or wrong choice, except for newsprint, which yellows over time—only what works best for your pencil style and desired results.

I've tried a lot of different papers over the years. Because of the style of drawing I do, I like a very specific type. That's not to say it's the ultimate paper for you—I firmly believe you should experiment. However, to get the effects you'll see in this book, you'll need to use plate-finish (smooth) bristol board. Why bristol board? Surfaces that have more texture than bristol board don't blend the same—the graphite bounces across the top of the rough surface and doesn't easily get into the "valleys." You might have problems getting a smooth finish. In addition, rougher surfaces "grab" the pencil lead and require you to maintain good, even strokes—which can be difficult for a beginner.

In addition, keep several spiral-bound sketch pads handy for travel. Sketching live children is a challenge, but it develops the eye. We'll cover more about this in the section on gesture drawing (page 42).

And finally, an often overlooked but necessary type of paper is tracing paper. It's useful for tracing (of course) and transferring drawings, and also as a barrier to protect your drawings from the oils on your hand.

Smooth, Heavyweight Paper
A smooth, heavyweight paper makes blending easier when drawing children.

Tracing Paper Serves as an Oil Barrier
Place a piece of tracing paper under your hand as you shade to keep from transferring the oils from your hand to the paper and to keep from inadvertently smudging the wrong part of your drawing.

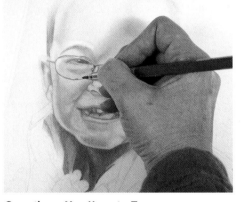

Sometimes You Have to Trace
Objects such as glasses, when viewed straight on, must be the same size and shape because they're mechanical. Trace one side of the glasses, then turn the tracing paper over and check the other side for symmetry.

Pssssst!

I buy my paper from an online supplier once I've determined what paper I need. It hasn't been touched by oily hands like in an art store. When I buy from a store, I purchase sealed pads.

Drawing Table

You need a place to lay your supplies and your drawing paper that allows you enough room to draw comfortably. A full-size drawing table provides a firm, steady surface and enough room to rest your arm as you draw. The table should angle so that your drawing paper is parallel to your eyes, which minimizes the chance for visual distortion as you work.

I always remove my drawing paper from the pad and place it on a drawing table unless I'm working in my sketchbook. In that case, I'll place a piece of cardboard between the pages to prevent transfer.

If you have limited space or want to carry your studio with you, a portable drawing table with short legs that perches on the edge of a regular table is handy. Legal-size clipboards, smooth Masonite and other drawing boards may also be used.

Drawing Table
I have a wonderful drawing table with matching light, chair, tray and *taboret* (set of portable drawers). I have several thingamajigs that twirl around and hold a variety of nifty pencils and erasers. Needless to say, I look major cool when I draw. My husband, Rick, has a mammoth drawing table. It's sort of a "guy thing."

No Distractions
I've faced my table away from the window to avoid distractions while drawing. I can think of all kinds of things to do outside if given the stimulus of a window.

Reference Photos

I embarked on this drawing book by immediately taking a vast number of photos of every child within range. I learned something from child photos—the little tykes don't hold still. They race around, turn their heads just as you snap the camera and otherwise do everything in their power to make step one difficult. Yes, step one in drawing is to take a photo. We'll talk about gesture drawings and life drawings later; for now you'll want to start with photos.

Going Digital

I mostly use film photography, but digital cameras are progressing at a fast rate and are easy to use. Just be sure your photos are clear and have enough detail. Some digitals look great on the computer but terrible when printed. If that's the case, you can draw while looking at your computer screen. It's easy to transfer a digital color photo to black and white for drawing purposes.

Lighting

I prefer a strong light source because I like the play of light and shadows on a face. The problem may be, however, that too much sunlight can make for squinty eyes, black shadows and not enough contrast. One way to solve the problem is to photograph your subjects on an overcast day. You'll get some light patterns without the blasting sunlight. You can also photograph in the shade on a sunny day. You'll achieve contrast without the bright sun. Select photos that describe the contours of the face rather than those that look like something spilled on the picture (the effect you might get when drawing a face dappled with sunlight through a

tree). I've discovered that unless you also draw the tree, you'll end up with a blotted face. Direct light may place the face in total darkness, making drawing it almost impossible. If this happens, you might try to lighten the face using a photo manipulation computer program.

Size

I realize it seems like the most obvious thing in the world to make your photo as large as possible, but I still have many students bring in snapshots where their darling child's face is smaller than my fingernail. Size does matter in drawing, because if we can't see, we can't draw.

Copyright

It is important to address the issue of copyright. Photographers work hard to improve and grow in their craft, and their photos are their art. If you get the photographer's permission to draw from his or

her image, go ahead. Don't assume, however, that because your darling grandson is in the photo that you can draw from it. Play it safe and ask.

Places to Find Photos

I can't think of a better resource for drawing faces than the wonderful antique photos you have in your old family albums. Start by scanning the photo (if you have the ability to do so; if not you can have it done for you). Enlarge the scanned photo so that it's easier to see and keep the original nearby. Antique stores, garage and estate sales and other such locations may also provide a treasure trove of photos to draw. Also, some books and magazines have great photos for practice, but remember these are just for practice, not publication or sale.

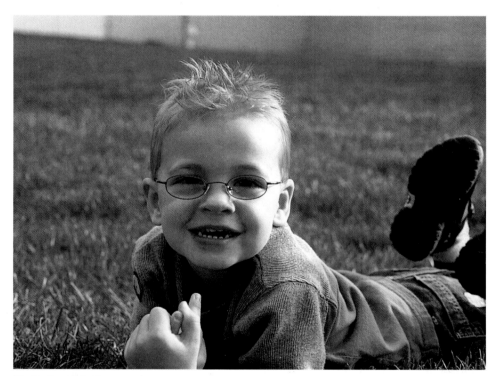

That's the Ticket!
Try photographing your subjects on an overcast day to achieve good contrast without squinty eyes or dappled shadow.

Bigger Is Better
The photo above left is nice, but the full figure is too small to see facial details. Above right is the size you need for details.

Pssssst!

The secret to good photos? Big. Clear. Interesting angles.

Shopping List

- *2H, HB, 2B and 6B pencils*
- *Pencil sharpener or lead pointer*
- *12-inch (30cm) C-Thru ruler*
- *Circle template*
- *Kneaded and white plastic erasers*
- *Electric eraser (if you can afford it)*
- *Bristol board*

- *Tracing paper*
- *Soft brush*
- *Drawing board*
- *Set of paper stumps*
- *Set of tortillions*
- *Reference photos*
- *French curves (for drawing glasses)*

Antiques
Antique photos, unless from a book that may have copyright protection, make fine drawings because they are often very clear and in black and white. Think about drawing your grandmother as a child.

Editing Your Photos

Just because something is included in a photo doesn't mean you have to draw it. It is OK to alter or change what appears in the photo if it isn't necessary or doesn't add interest. When it comes to clothing, for example, a busy print might distract from the portrait, so keep the shading, but drop out the pattern.

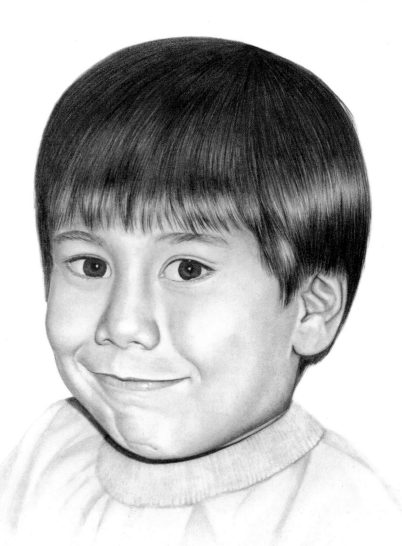

Favorite Photo
Robert Asuncion was the only child of dear friends. He passed away far too young. We wanted to give them a gift of drawing, so we asked for their favorite photo.

Robert
We removed the party hat, added the top of his head, and left out the busy shirt.

Through Eyes Filled With Tears

There's nothing more painful than the loss of a child, and your drawing has the ability to make a child's face a work of art for all time. By adding shading, lengthening and broadening the nose, adjusting the mouth and filling in the jaw, it's possible to get a glimpse of what that child might have looked like if they had grown older.

Composite Drawings

I'm a police composite artist, but in this book we're talking about a *different* type of composite. Here, we're talking about putting together several people from several different photos.

After all, trying to photograph a litter of puppies, four little children or both sets of in-laws who live two thousand miles apart is way too much work. You can create a composite drawing of family members who have passed away, every dog you've ever owned or other things that could never be grouped together for a photo. Composite drawings can enhance reality or make the impossible possible.

When looking for composite photos, choose those that might tell a story. For example, Rick drew a man that had been a fish and game warden. He drew the man's pet cougar on his lap (BIG kitty, kitty, kitty). I like photos that share something in common or have a common theme—age, or each member in uniform, or with the same expression. You're only limited by your imagination, and, of course, reference photos!

Secrets to Good Composite Drawings

There are two tricks to making good composite drawings. The first is getting the proportions of the combined elements correct so that everything looks like it naturally goes together. The second is a consistent light source, especially when lighting is different in every photo. You may need to do a bit of research or ask questions when combining images. Your research might include finding additional photos of the same person with different lighting or checking the scale and sizes of various objects in the photo. Ask questions about the photo if possible—was the puppy baby Norman clutched in his arms a Saint Bernard or a beagle? When

you combine baby Norman with Great Grandpa Thomas in your composite drawing, you can derive information about proper scaling measurements from such questions.

As you collect your drawing materials and photos, think about ideas for your art. A drawing isn't like a photo— it doesn't have to be limited to time and place. Drawings can show not only the reality of today, but also a memory of yesterday. Drawings can bring generations together in a unique moment of time. Drawings can show dreams, hopes and most of all, love.

For Example

One great composite drawing to try involves placing several generations together; for example, various family members at the same age. Make sure the faces are positioned in an interesting direction and are about the same size if the same age. The images don't have to be looking in the same direction, but you probably don't want them looking away from each other, either.

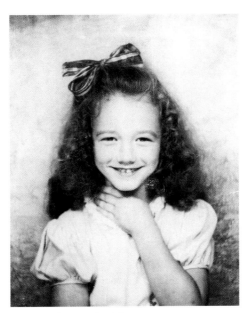

Step 1: Choose the Photo
Shirley Marcey Parks passed away suddenly a few months before the birth of her first grandchild. We found a photo of Shirley at about the age of seven.

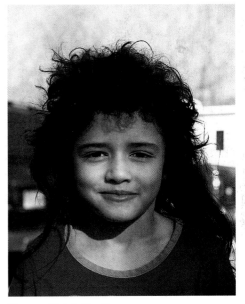

Step 2: Match the Faces
We had taken numerous rolls of photos of Shirley's four grandchildren. From these photos, we found one of Skylar, her second-oldest granddaughter.

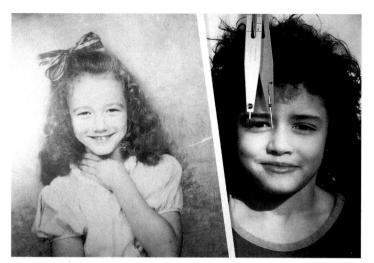

Step 3: Scale the Faces

Both Shirley and Skylar are about the same age; therefore we can use the same scale, that is, make both faces the same length. I scaled both photos by measuring the width of one eye and comparing it to the width of the eye in the second photo. The face length may vary, and noses may vary, but eyes tend to be uniform in size. I used a photographic computer program ruler to make sure both were about the same size.

Finished Composite

Separated by more than fifty years, Shirley and Skylar each represent a slice of their respective generation. Shirley, in both name and dress, is like the Shirley Temple icon of her time. Skylar shows her ethnic blend and the casual attire of today. They both share some of the family's features, so together they make a wonderful composite of the Marcey Parks–Lindsey family.

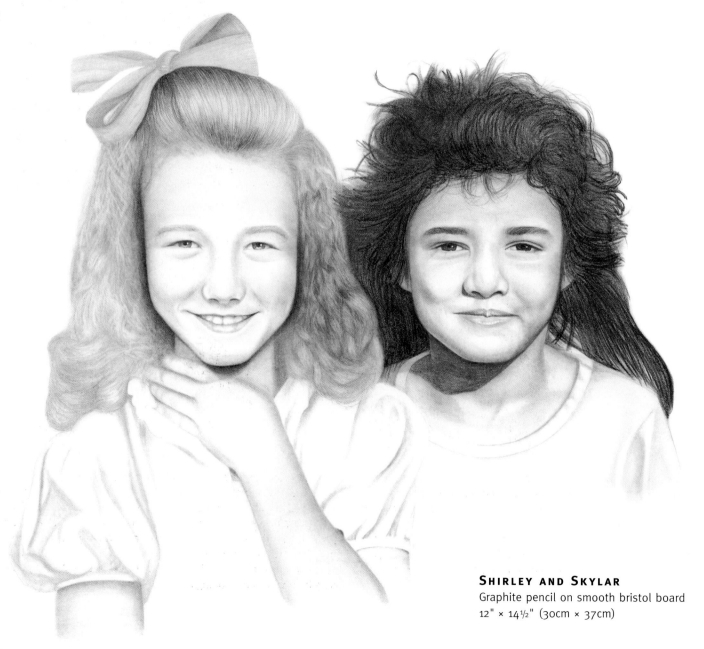

SHIRLEY AND SKYLAR
Graphite pencil on smooth bristol board
12" × 14½" (30cm × 37cm)

Power Jotting

We need to warm up and make our drawing skills limber. Dancers stretch, musicians play scales, writers stare blankly at their cup of coffee and artists often doodle.

Sharpen your pencils!

Exercise 1: Scribbling, Erasing and Smudging

Scribble your heart out. No, I'm not losing my marbles—you need to get the feel of the pencil and the paper. Some pencils scratch the paper, some glide. Some papers snag your lead, some caress. Push on the pencil, then hold the pencil lightly. See what kind of a line a dull pencil makes compared to a sharp one.

Get out your eraser and erase many of the lines. Can you do it? Have you scored your paper? Are there remaining black marks? Which pencil felt good and erased well?

Now get your paper stump and start smudging. Which leads smudge? You may have to go back and rescribble. Make neat scribbles and messy scribbles. What happens when you smudge them?

Exercise 2: Pencil Handling and Shading

Feel better? Yep, we're getting over the fear of using white paper and new tools. Now let's direct our scribbling to shading. Turn your paper over or get out a new sheet.

Your pencil strokes should be quick, yet controlled marks. Start with a black edge, then move your pencil back and forth, getting lighter and lighter as you move across the paper until you can no longer see your stroke.

Exercise 3: Smudging With Paper Stumps and Tortillions

Just as your pencil strokes must be smooth and even, your paper stump must be used with correct pressure. The paper stump is used for larger areas and is to be used on the tapering side—not the tip. Using the tip applies too much pressure in too small an area, causing a scruffy appearance. The tortillion is designed to be used in small areas and only on the tip because the rolled side will look like corduroy skin. Practice using both with your shadings from Exercise 2.

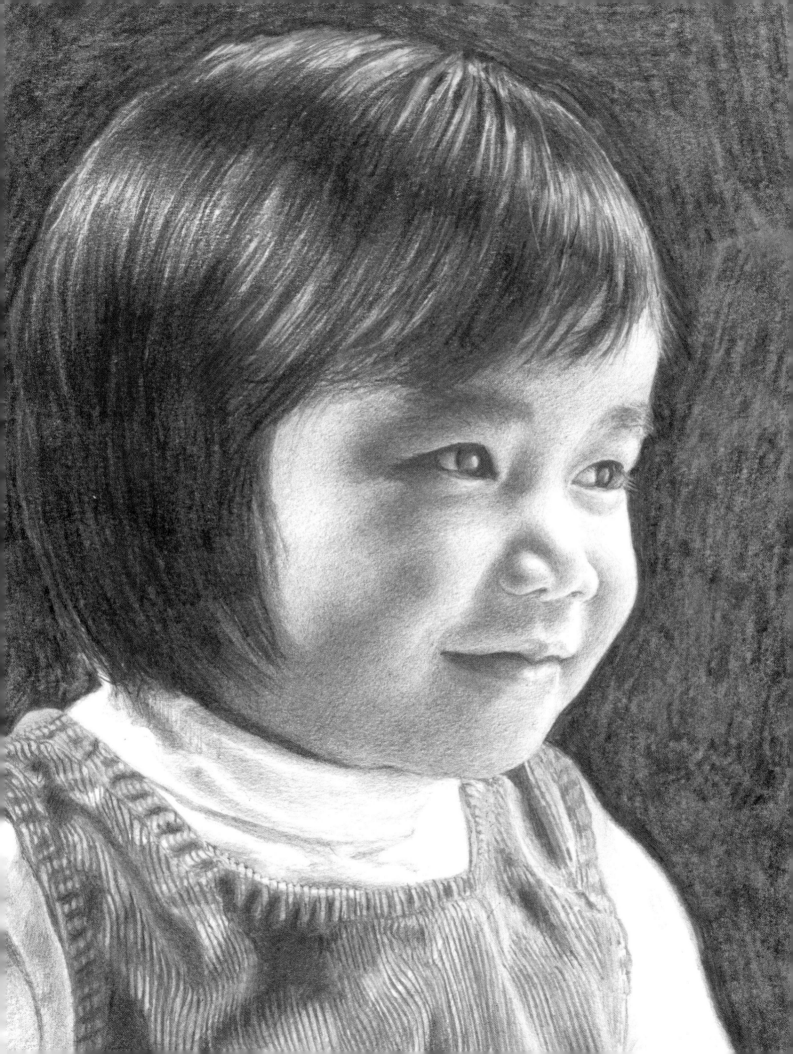

The Big Picture

I don't think I've ever taught a class where there wasn't at least one student who asked about drawing their child or grandchild. That may not sound unusual to you, but many of my students are taking some type of forensic art class. These often enormously burly cops are learning how to draw the faces of bad guys, but then during their breaks, they're sketching the faces of their beloved son, daughter or grandchild.

The problem is that it's not easy to take composite information and apply it directly to drawing children . . . unless you want your offspring to look like a wanted poster.

I've found that the desire to capture the likeness of a child or grand-child is a universal yearning. In this chapter we will explore what makes drawing children so challenging.

Practice Made Perfect
When drawing your child or grandchild, it can be tough to avoid seeing through the eyes of love. Develop your critical eye by practicing on subjects other than your loved ones.

MAGGIE RENNIE
Art by Greg Bean
Graphite pencil on smooth bristol board
16" × 13" (41cm × 33cm)

The Problem Is . . .

Drawing can be difficult, and the most challenging type of drawing has to be portraits. Let's face it, if that bowl of fruit has a lumpy kumquat, or that landscape has a few too many trees, what difference does it make? But a lumpy head or a few too many eyebrow hairs can make a huge difference in portraits. Accuracy and precision in drawing the human face requires a trained eye. Drawing is about seeing. Seeing things differently than you've ever seen them before.

Let's take a long look at the way we see things. As we read a sentence, the hmuan mnid deosn't raed ervey ltteer in a wrod. The frist and lsat ltteer msut be in the crorect lcoatoin, but the rset can be ttoally mseesd up. We raed the wrod as a whloe.

Did you understand those last few sentences? Sure. That is because we take in the world around us as a whole, place it into a pattern of understanding and forget about it. Our mind takes shortcuts.

Take another example: the U. S. penny. Don't peek now, but who is featured on the front? Did you guess Abraham Lincoln? Excellent. Which way is he facing?

Once again we realize that we see without really seeing. Try this with a dollar bill, or the pattern of your favorite shirt. We can recognize the pattern, but we can't really draw or describe it well. We need to train our eyes to slow down, pay attention and not generalize.

Natural Artists
The people I refer to as natural artists are those who are able to see and draw without training. It's interesting that only a small percentage of artists can draw anything they see. Natural artists will say such things as, "I like drawing buildings, but I can't draw people." Or "I'm good at still life, but terrible at animals." What a natural artist is saying is that they have learned how to see, artistically, only certain things.

Moment by Moment
Making drawing even more of a challenge is the fact that we see, in the artistic sense, briefly. What I mean is that the first time we start to draw details, they may be clear to us, but the longer we look at the subject, the more elusive the details become. Not only does our mind take shortcuts, it stops observing altogether. It's as if our mind says, "OK, now I get it, let's move on." The details that were once clear are no longer obvious. This is why, after taking a brief respite from your artwork and walking away, you can see the errors in your work so clearly upon returning. Your mind stops processing the subject, then reboots after taking a break.

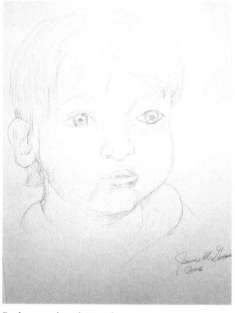

Preinstructional Drawing
Jeanne Gorans is one of my favorite people (along with husband, Bud) and generously offered me her work from the first class she attended with me. This is her preinstructional drawing, sketched without looking at a photo reference. Therefore, she is drawing from her memory, not from what's in front of her. The image is stylized and not accurate.

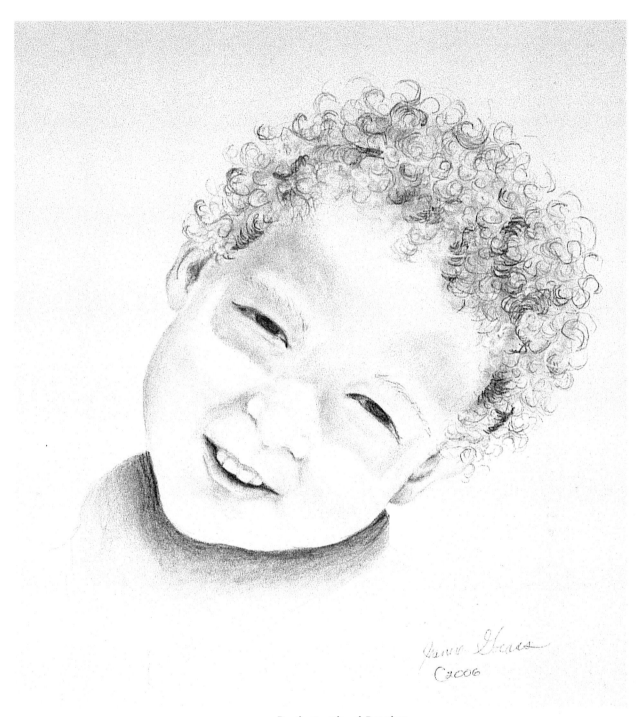

Postinstructional Drawing

After two days, Jeanne has studied faces in general, learning what to look for in the facial features. She can now look at a face in a photo and see shape and value (lights and darks). She measured her grandson's face, so it is correctly proportioned, and she used guidelines to place the features. Her eyes have slowed down and now pay attention to the details of the face.

Perception

Seeing as an artist is not about vision, the function of the eyes. It's about perception, the mind's ability to interpret what we see. A good definition of perception is the process by which people gather, process, organize and understand the world through their five senses. With this in mind, there are two important points that every artist should know about perception.

First, each of us has a filter that affects our perceptions. By shaping your filter to meet your interests, you can build upon your dictionary of patterns and develop your artistic skills. However, it can be a challenge to alter your perception without study and practice.

This brings us to the second point: Perceptions are powerful—so powerful that they don't change unless a significant event occurs. In drawing, this significant event is training. The goal of this book is to give you tools to bypass that filter and train your mind.

Filters

Perception filters exist solely to keep us from overloading on too much information. If we didn't have filters in place, we would suffer from sensory surplus. As handy as your filters may be in everyday life, they must be shaped and altered for you to become a proficient artist.

One filter I'd like to bypass right away is edges. I became aware of this when teaching children to paint, and it is the same filter still firmly in place in adulthood. Our perceptions dictate that objects must have strong outlines and defining edges.

The Reality
When children (and many adults) are shown a subject such as a leaf, all the information they need to draw is present. It has a shape and color.

The Perception
Although all the details are present in the photograph, the filter of perception means the aspiring artist draws what is present in their mind—the outline of the leaf. There are no thick, dark edges present in reality.

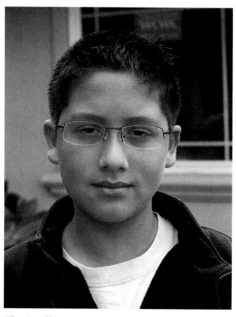

The Reality
The reality of a face is that the nose begins in the forehead and is shorter in length than we tend to see it.

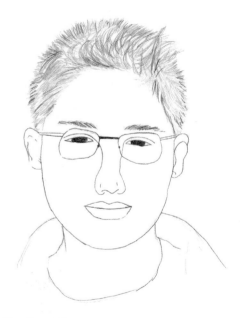

The Perception
We perceive the nose as originating somewhere around the eye area and as longer than in reality. The perception of the nose as overly long is so prevalent that many drawing books have incorrect proportions.

Pssssssst!

The secret to drawing? Learning to see by using tools to overcome the filters of perception.

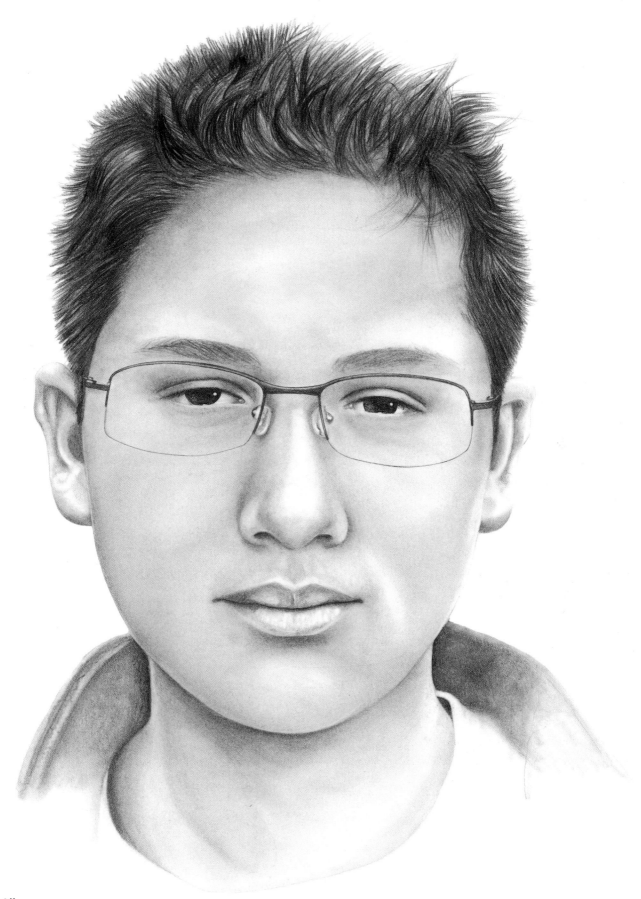

Capturing a Likeness
Understanding how your filters work, and then turning them off, will allow you to draw what you see, not what you think you see using memorized patterns of facial features.

NICHOLAS GONZALES
Graphite pencil on smooth bristol board
16" × 13" (41cm × 33cm)

Through the Eyes of Love

If drawing is challenging and drawing people is even more difficult, then drawing children is the granddaddy of all challenges. Not only do you have to be exact and capture every subtle nuance of shape and shading, but you're drawing something through the eyes of love. It's very, very hard to objectively view someone you cherish.

Unless you have a great desire to torture yourself, draw from a photo rather than life. You're at the mercy of the accuracy of the photo.

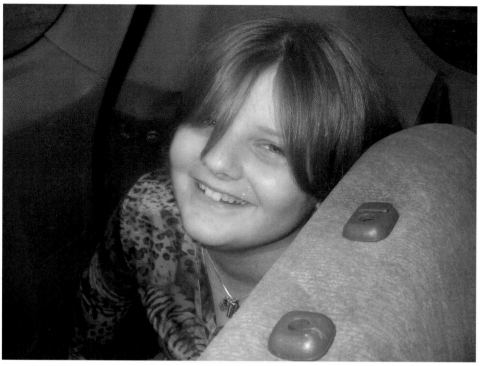

The Reality
The photo of Kym has all the necessary information from which to draw: the proportions, shading and shapes of the various facial features.

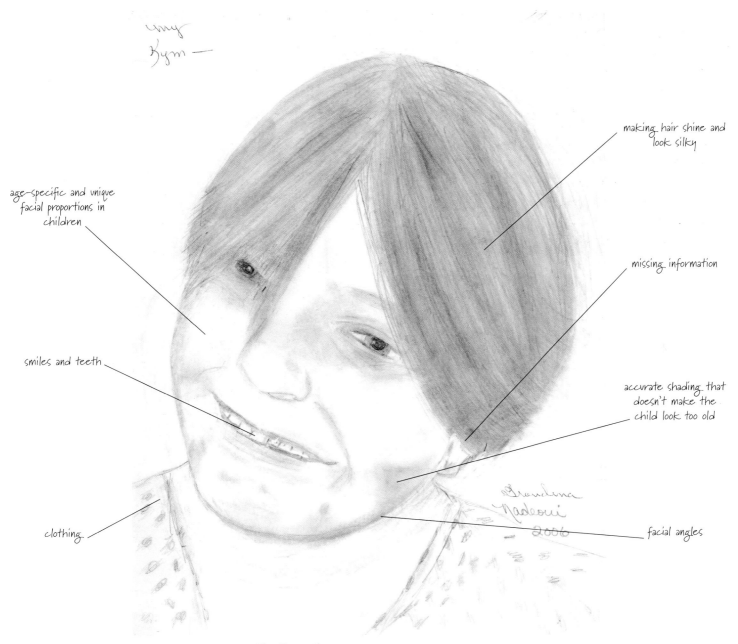

age-specific and unique
facial proportions in
children

making hair shine and
look silky

missing information

smiles and teeth

accurate shading that
doesn't make the
child look too old

clothing

facial angles

The Perception

Although much of this drawing is accurate, it's the little details that
would make the drawing more real. In this book, we'll explore the big
drawing picture as well as the subtle details to drawing children. We'll
be looking at children's faces (and their whole bodies) with a new eye.
Some of the special challenges we'll address include age-specific and
unique facial proportions in children; facial angles; clothing; making
hair shine and look silky; accurate shading that doesn't make the child
look too old; and smiles and teeth.

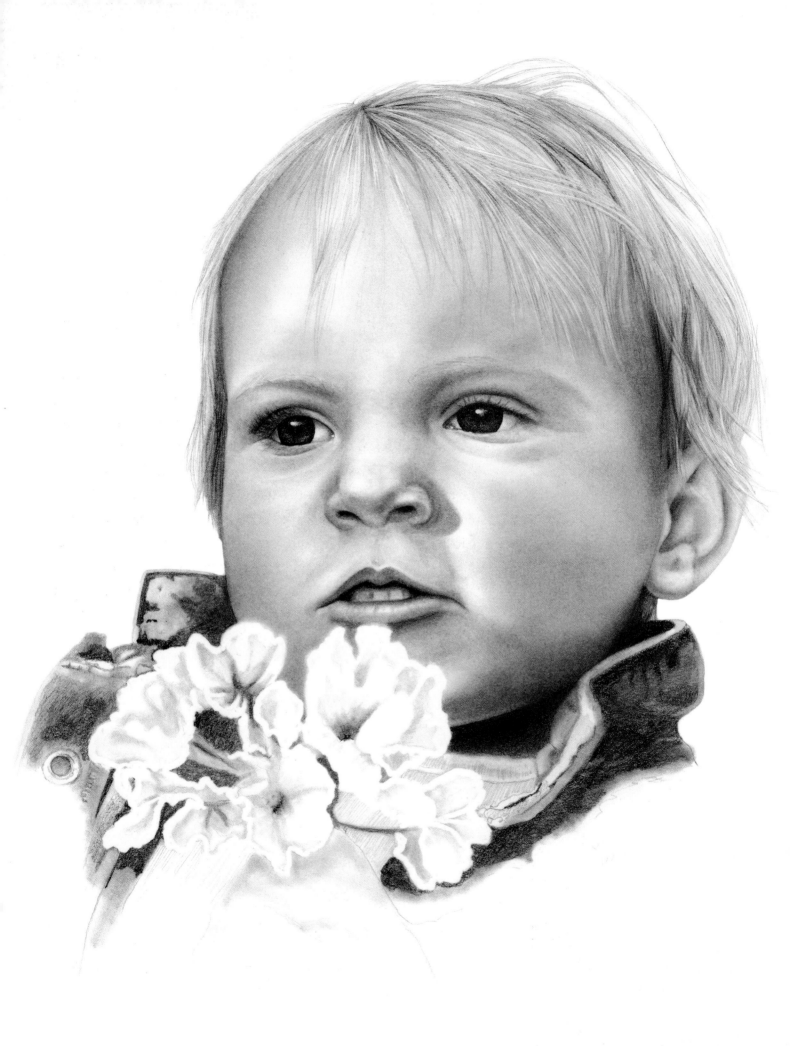

Pencil Poetry

Drawing children necessitates the development of three skills: training our eyes to see the shapes of the face, using mechanical tools for proportion and basic pencil skills. All three are related.

In the last chapter, you began working on the first skill by training your eyes to see facial shapes, learning how to see and to overcome the perceptions that we have about drawing so that we can draw well.

The second skill necessary to drawing is mechanical. Most artists use some form of mechanical device (such as a ruler, proportional divider, circle template, or even their hands) to help establish an object's scale and proportion. Experience and overall drawing practice may decrease the dependence on mechanical tools, but for emerging artists, they are useful.

Finally, you must work on your pencil skills—the physical application of graphite to paper. You need to know how hard to push on a pencil, how to control pencil strokes and how to blend lines. You'll work on pencil skills in this chapter.

Your Artistic Signature

Many artists, art teachers and critics are fond of talking about creativity—developing a creative approach, exploring your Inner Sense of Being, becoming one with the pencil. . . . Actually, I don't really know that they say that *exactly*. The irony in stressing creativity is that when you try something new, the response comes back, "But that's wrong, this is how you do it!" And you wonder why artists cut off their ears.

Your style of drawing is unique. It's your artistic signature. There isn't a right or wrong way to sign your name, only legible vs. illegible signatures. Your artistic style is the way you apply the pencil lead to the paper, the shading techniques you use, your choice of subject and what you include or exclude from your drawings.

How you choose to draw is part of your journey. I'll show you how I draw and shade to get you started (because it's fast and easy), but it isn't the only way to express yourself.

My husband, Rick, has a different style of drawing that works well for him. I love his drawings, but I'm too impatient (or lazy) to draw his way. Rick uses his pencil more than I do; building up the values (lights and darks) through pencil strokes, and only occasionally blending his strokes with a paper stump. It takes more skill in applying the strokes than my technique, which is blending with paper stumps and a chamois.

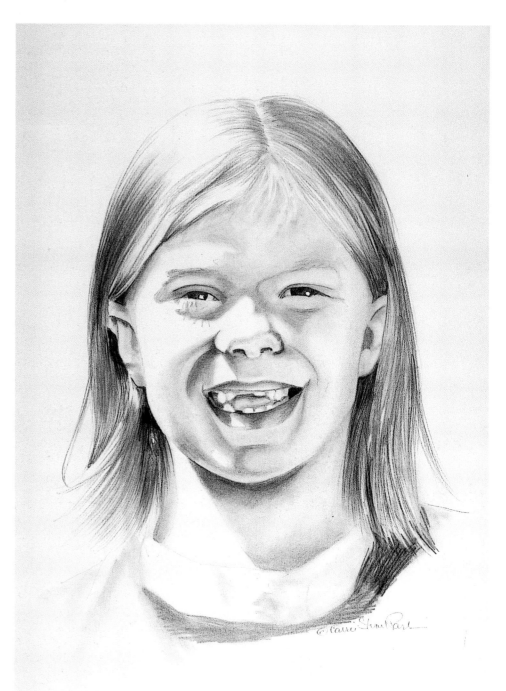

Aynslee Stuart
This is a drawing of Aynslee Stuart. I use a paper stump and then blend to create my drawings. Blend the pencil strokes with a "seasoned" paper stump. To create a seasoned paper stump, rub its surface over a dark scribble, picking up graphite on the side of the paper stump. It's a relatively fast and easy system to learn, and it gives good results. When Rick sees my drawings, he usually asks, "You're not done with that yet, are you?" It's a wonder we stay married.

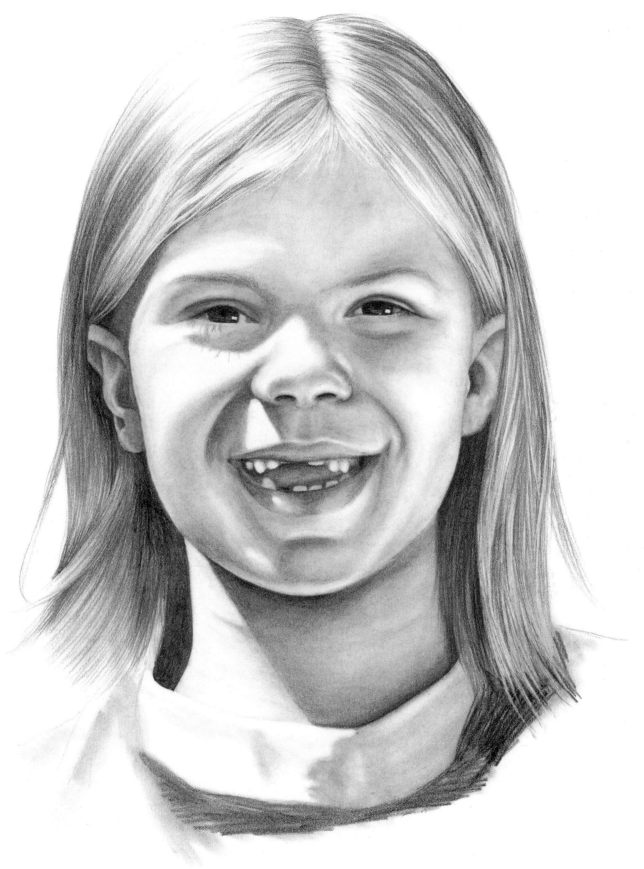

He Calls It Precise
Rick's drawings are wonderfully detailed. They display beautiful handling of the graphite and are works of art. I think he's anal. He calls it precise. It takes longer to do his type of drawing and requires more control of the pencil and different blending techniques, but it yields great results.

Pencilling Techniques

Three pencilling techniques to try are hatching, crosshatching and circulism. You can usually choose one of these techniques to use throughout your drawing.

Hatching

Hatching involves drawing parallel lines on your paper. These lines should be varied at the points where they begin and end to prevent unwanted hard edges from occurring. Vary the distance between the lines to create lighter or darker areas. I think Paul Calle is the finest artist using this skill, and have just about worn out his book *The Pencil*.

Hatching may also be an interesting effect if all the lines go in the same direction, giving the drawing a more stylized image.

Crosshatching

Crosshatching is lines, um, crossing the hatching. Very clever name. Crosshatching starts the same way as hatching does, with parallel lines. Once the first set of lines is drawn, a second set is placed over it at an angle. If more depth is needed, a third or fourth layer (or as many layers as necessary) may be added to create the desired darkness.

Hatching and crosshatching are considered useful styles for creating shadows when drawing in pen and ink, although they may also be used in drawing.

Circulism

The third technique I'd like to touch on is circulism (sometimes called scumbling). This stroke is a series of interlocking circles that may or may not be blended later. You must keep your strokes even and your pencil on the paper. Many colored pencil artists use circulism on their work to build up the layers of color.

Hatching

Crosshatching

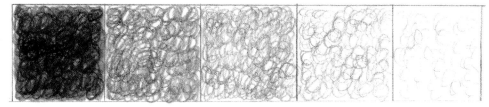

Circulism

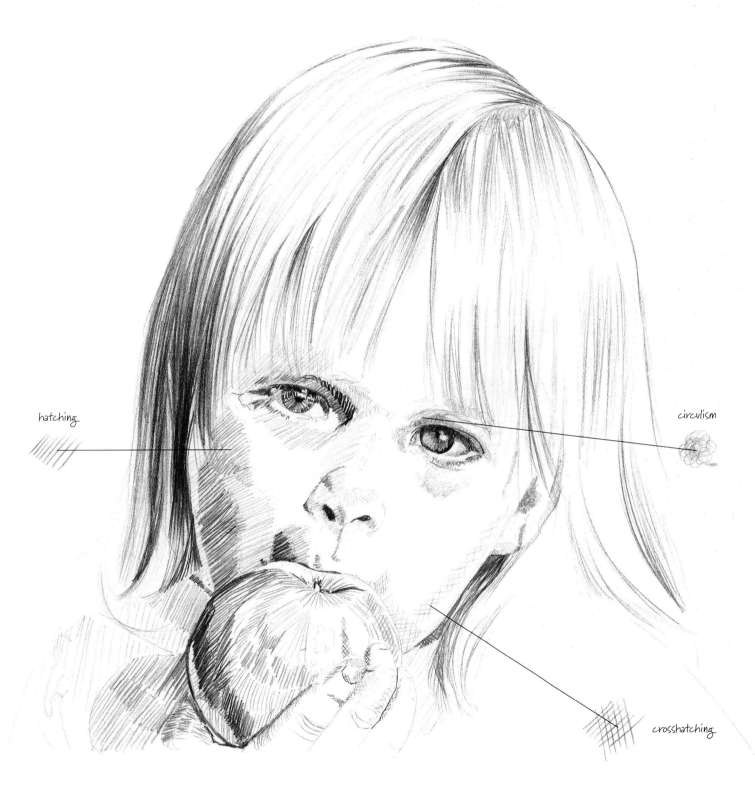

hatching

circulism

crosshatching

Choose a Style
Many artists choose one technique for their
drawings rather than mix styles within the
same piece of art. Experiment with your art
by trying out each style.

Contour Drawing

The goal of contour drawing is to explore the roundness and shape of your subject as your pencil and your eye work together. There are two types of contour drawings:

- **Regular contour.** In a regular contour drawing, you have the freedom to look at both the subject and your drawing as you work.
- **Blind contour.** A blind contour drawing, as the name suggests, requires that you lock your gaze on the subject entirely, never looking down at your hand as you draw.

Both types involve placing your pencil on a piece of paper and not lifting it until the drawing is complete. You draw around the outside of the subject and drift into the interior of the subject, all while the pencil is pressed to the paper. The goal of this chapter is to explore the roundness and shape of our subject with your pencil. We will be using contour drawings as warm-up exercises.

How to Begin
Get into a comfortable drawing position. Place your pencil in the center of the paper. Don't lift your pencil! Find a starting point on the subject with your eyes. Track around the subject with your eyes, keeping your pencil at the same speed. Remember, if it's a blind contour drawing, you must keep your eyes on the subject!

Special Note: Subjects

Although we used a photo to create these contour drawings, anything will work. Your hand makes a very good subject.

Also, contour drawings don't always have to be of a lone object. You can do a contour drawing of an entire scene or landscape. Though your pencil shouldn't leave the surface of your paper when you are drawing just one object, it's OK to quickly lift your pencil when drawing multiple objects if there is dead space between them. Only do this when necessary, though. The space between the objects should be significant enough to justify lifting your pencil.

Blind Contour Drawing Results
Your blind contour drawing should end up looking like this blob of lines. Yep, it's supposed to look weird. The trick here is to teach your eyes (that is, your mind) to really look at something, to slow down and not process it too fast.

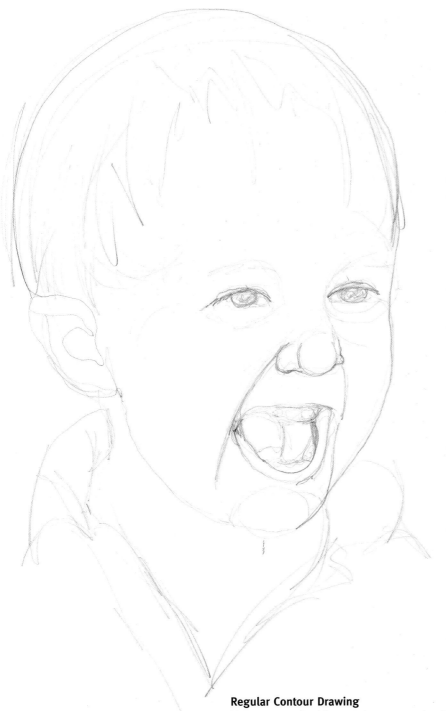

Paxton Wecker has offered to be your model for a contour drawing. Take out your pencil and paper and explore.

PHOTO BY DONNA RUNGE

Regular Contour Drawing
You get to peek with a regular contour drawing, and your sketch should look more, um, human. Do you notice how your pencil is capturing the roundness and character of the subject?

Gesture Drawing

Another useful warm-up exercise is gesture drawing. This is quick sketching to capture the movement and action of the subject. A gesture drawing is accomplished by sketching a series of circles and ovals to find the general round shapes within the subject, not a real likeness.

Gesture drawings are typically of live subjects, although you can also practice with a photo. If you choose to draw your child or grandchild, you'll need to work fast. Try not to spend more than a few minutes on any gesture drawing.

Loosen Up
Gesture drawings should be loose and free, capturing movement and life. Work quickly. Seek areas of roundness and angles.

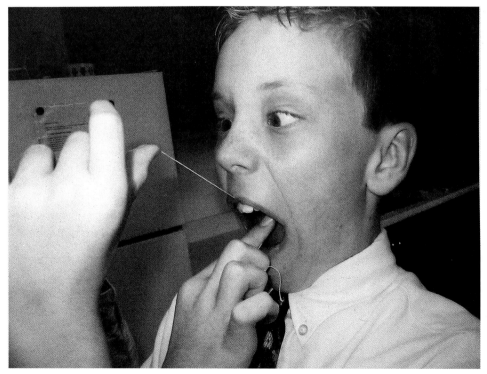

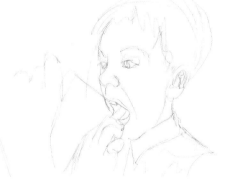

You Try It!
Practice your own gesture drawing using this photo of Orion Howard flossing his teeth. Find the areas of his face, hand and arm that are round and oval. Explore the shapes with your pencil. Keep your drawing loose and free. You're not trying to make an exact likeness; just get a feel for the subject.

PHOTO BY NADEOUI EDEN

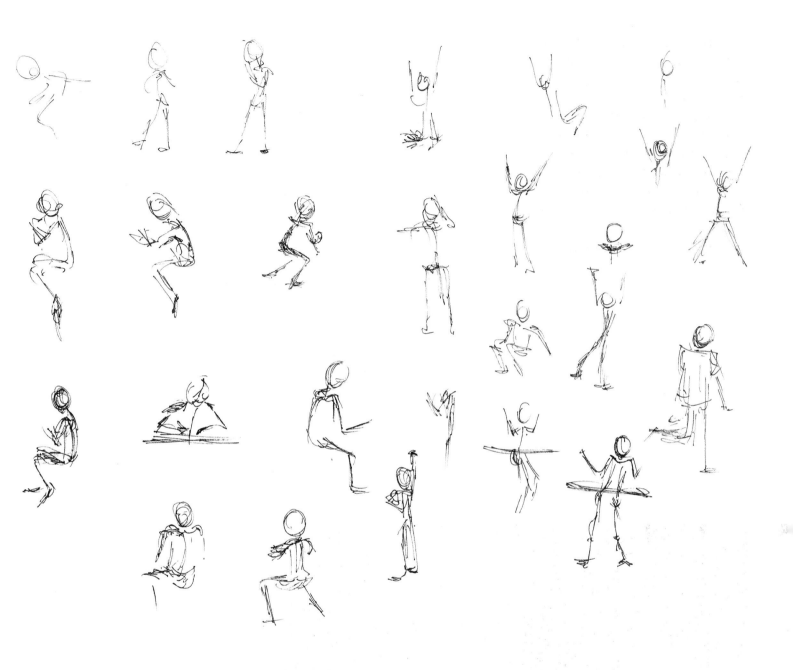

Challenges!
Marlene Hirose, a nimble-fingered artist we met at a sculpture work-shop, sketched the flying figures of Miss Lim's kindergarten class at Baker Elementary School in San Jose, California. These drawings are loose and don't attempt to create a likeness of a particular child. This type of sketching forces you to depict the essence of your drawing and helps you to discover the most important aspects of your subject while using the fewest strokes to describe what you see.

Introduction to Shading

Shading is often the last technique you apply to a drawing. It requires good pencil skills, correct pressure and application of the pencil and blending tools. Shading is what typically separates the soon-to-be artist from the skilled professional. Why? Because shading takes practice. We will practice shading in greater detail later in the book. For now let's familiarize ourselves with the basics.

Ways to Shade

There are a variety of ways to shade including smudging, blending with your pencil, hatching, crosshatching and combinations of these techniques. Certain pencil-paper combinations are more successful than others. Smooth bristol board allows you to blend using paper stumps. The more tooth (texture) on your paper, the less successful the paper stump will be in blending. The tooth of the paper can snag your lead and doesn't allow for smooth blending.

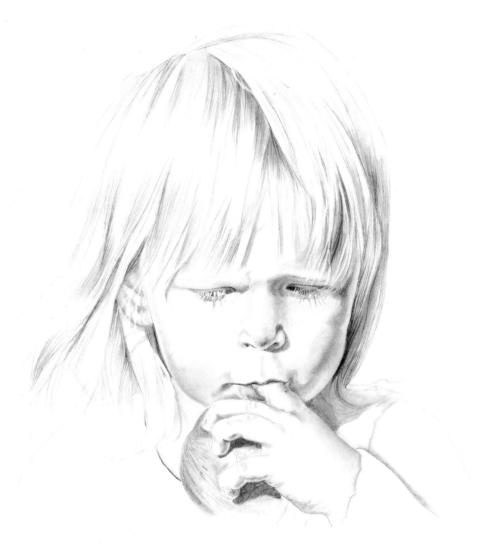

Putting It Together
Use blending and smudging tools to give the face a soft, childlike look. Hatch using linear pencil lines to create hair.

Basic Shapes

There are four shapes you should become familiar with: the cube, the cylinder, the sphere and the cone. These shapes and their shading form the basis of your drawings. If you can master the shading of these items, you've discovered one of the biggest secrets to drawing.

Shading Pattern

The pattern found in round objects is light-dark-light-dark. That is, where light strikes a round object it creates the lightest light. As we move from this lightest light, shadows form (dark). Just before the opposite edge from the lightest light, we encounter another light area, called reflected light (light). Then we reach the shadow area (dark).

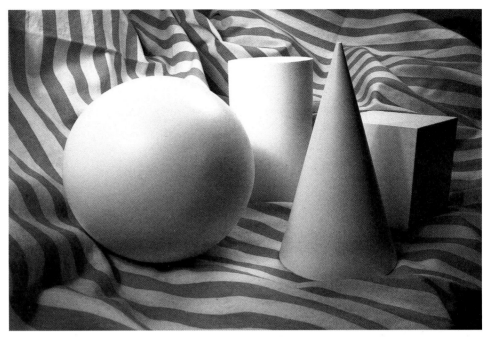

Basic Shapes
You can shop for examples or props of the basic forms in most art supply and craft stores. Use them in different lighting situations and with different backgrounds to practice shading each form. If you can accurately depict them, you are well on your way to drawing realistic children. From left to right: sphere, cylinder, cone and cube.

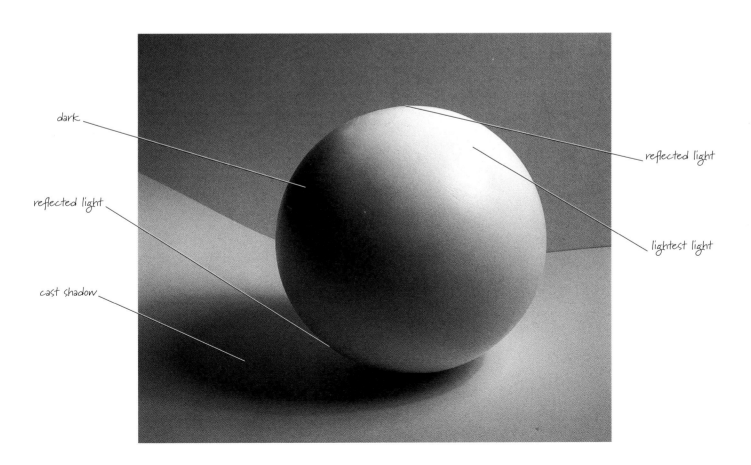

dark

reflected light

reflected light

cast shadow

lightest light

Practice Shading

Let's take a step-by-step approach to shading. Your pencil strokes should be smooth, close together and shift from dark to light.

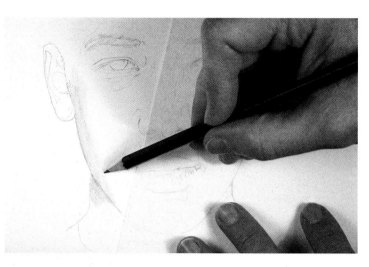

❶ Start Light

Begin with a 2H lead pencil and make numerous smooth marks close together.

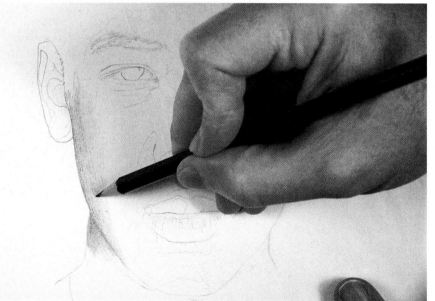

❷ Add Medium (Midtone) Shades

Repeat the same marks using an HB lead pencil, but this time don't make the marks completely over the previous lines. End the HB shading, creating a gradual tone moving from midtone to light. Stop your strokes about halfway across the lighter strokes.

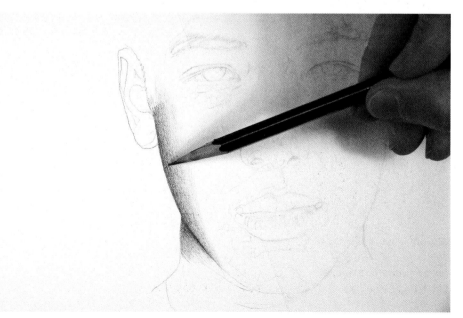

❸ Darken the Tones

Repeat the same process using 2B or darker lead, this time ending the dark area so as to create the darkest tones. By the third pencil stroke, you'll again end about halfway over the previous midtone strokes.

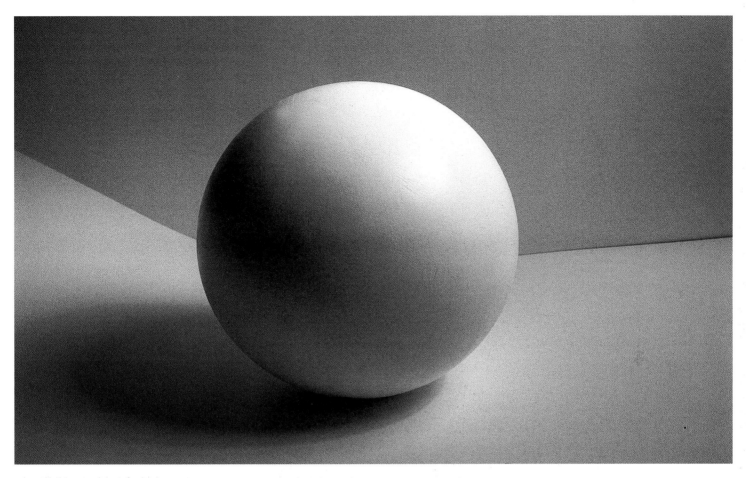

Shade a Sphere

Now it's your turn. Take something round, like
a small bowl, and use it to trace a circle. Use
the shading pattern found in the photo and
shade it as a sphere.

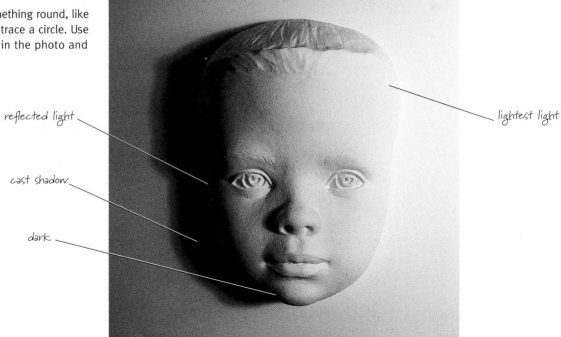

reflected light

cast shadow

dark

lightest light

Going Round and Round

Can you find the pattern of light-dark-light-dark in this photo?

Pencil Tones

Now it's your turn to apply the graphite and shade the face. You can draw, copy or trace this line drawing onto a piece of paper for practice. Start by looking for the darkest darks in the photo, then identify the lightest lights. Your lightest light is the white of the paper. The darkest dark is the heavy 6B lead. All of the other tones are between these two in the value scale. Keep your whites clean and work inward from your darks.

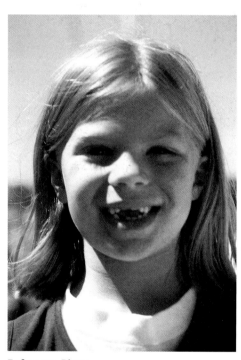

Reference Photo
Watch for the light-dark-light-dark pattern on the face. Squint to see it better. If you need to, cut a hole from a piece of paper to examine each area.

Your Turn
This is a line drawing of the reference photo. Practice shading to get the feeling of roundness. We'll cover individual features and how to scale them later in chapter five.

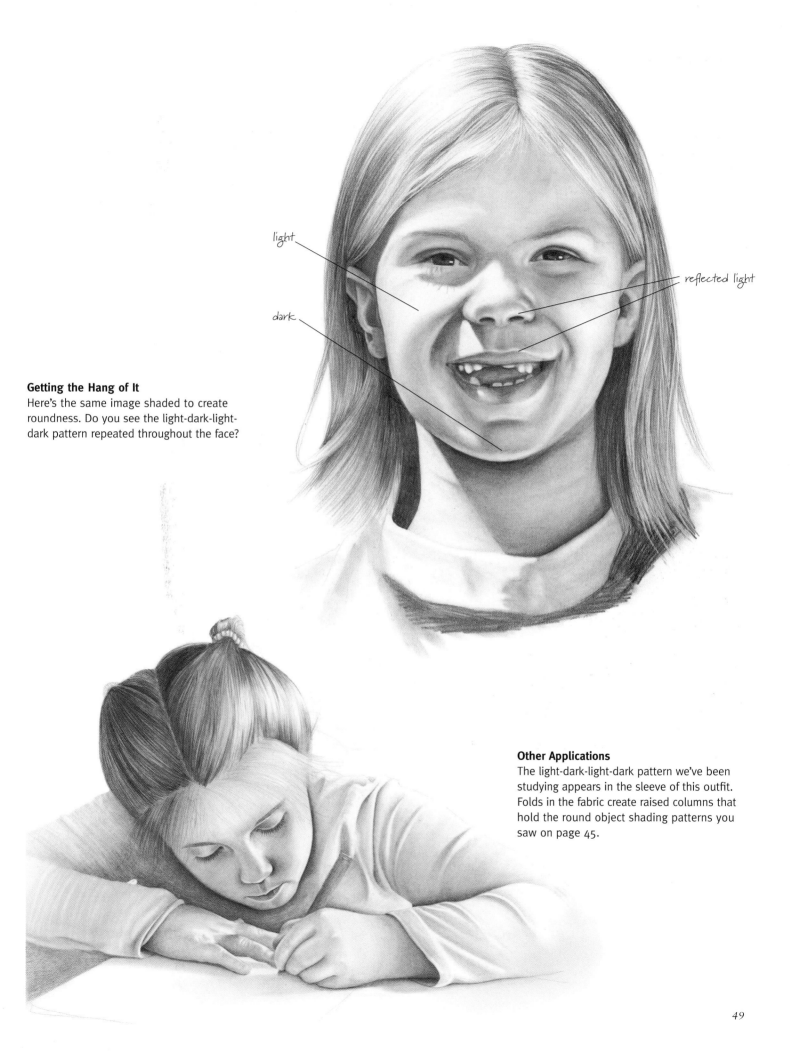

light

reflected light

dark

Getting the Hang of It
Here's the same image shaded to create roundness. Do you see the light-dark-light-dark pattern repeated throughout the face?

Other Applications
The light-dark-light-dark pattern we've been studying appears in the sleeve of this outfit. Folds in the fabric create raised columns that hold the round object shading patterns you saw on page 45.

Your Aging Child (A Really Big Secret!)

Perhaps the biggest secret to drawing children is that less is more. When rendering a child's face, the most common problem is that the child ends up looking too old. The proportions may be wrong, but most often it's that the shading is too dark. The amount of darkness in a photo is not the same amount of darkness you should use on your paper. If you shade the face too much, your child will age—rapidly.

Original Drawing
This is the original drawing. I've cut the amount of shading on the face to about half of what appears in the photo—especially around the eyes, mouth and nose.

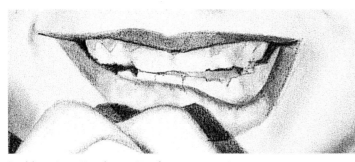

Problem Area Number 1: Teeth
Teeth can make a child look younger or older, depending on the size and spacing. Here I've closed the gap between the front teeth and made the other teeth slightly larger. Young children have baby teeth, which are smaller and usually have gaps between them. By making the teeth larger and filling in the gaps, I've made the mouth appear older.

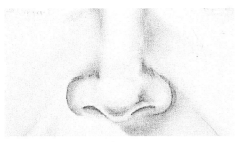

Problem Area Number 2: Nose
Here I've darkened the shading around the nose. As children get older, their noses grow downward and forward. If you shade too much around the eye area, it makes the nose look larger and the child look older. Keep the shading light around the eyes.

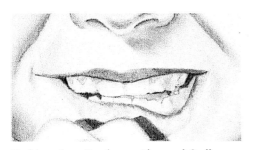

Problem Area Number 3: Lips and Smile
Children often have bright red lips. I've lightened the lip shading to make the lips paler and darkened the nasolabial folds (the deep creases that run from the side of the mouth to the nose).

Problem Area Number 4: Eyes
Too much shading under the eyes will age a portrait. Notice the bags under the eyes.

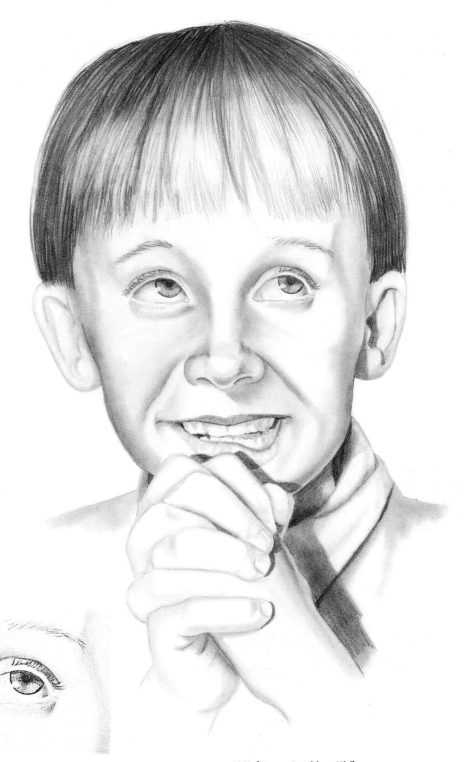

FLK (Funny-Looking Kid)
If you've found you have correctly proportioned your child, but the age is off, chances are you've created a FLK by overshading. The solution? Less shading in one of the problem areas.

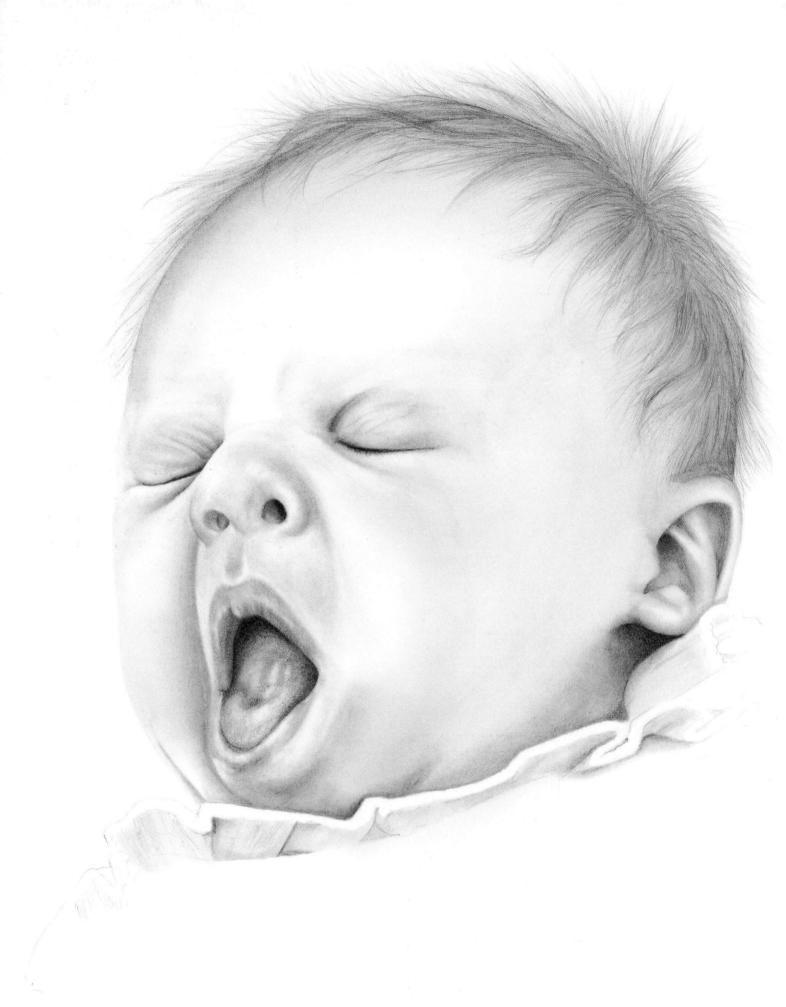

Facial Proportion

Capturing the likeness of a child can be challenging and frustrating. It involves getting the correct proportion and then bringing the face to life with the right shading. This chapter is all about facial proportion.

Unlike forensic art (i.e., drawing the faces of criminals), which is somewhat formulaic, drawing children doesn't utilize a formula for the "average face." A child's facial proportion depends on age as well as the specific angles of what you're drawing. Tiny, subtle errors in the face translate into an incorrect drawing.

Baby Faces
The facial proportions are unique to each age of life. A baby's face consists of a very large cranium (the bones that protect the brain) with a comparatively small lower face.

SUMMER STAPLES
Graphite pencil on smooth bristol board
17" × 14" (43cm × 36cm)

Proportion Without Math

We artists are simple folks. We don't like life to be too complicated and heaven forbid it involve any math! Assuming we wish to correctly proportion an object, we usually do so by comparing things. Our philosophy is simple: To proportion means to compare two items and decide if both items are the same or different sizes. If we want to draw an apple and a banana, how does the length of the banana compare to the apple? We can do this comparison by:

1. Buying two apples to see if they equal one banana in length.

2. Measuring the apple with a ruler, then measuring the banana with a ruler. (But that's way too much work and has the potential of requiring math.)

3. Marking the width of the apple on a piece of paper and comparing it to the length of the banana. I like this method best.

Now, I'm sure you're wondering why I'm talking about produce when you want to learn about drawing a child before he or she becomes an adult. I'll move off apples and on to the apple of your eye: your child or grandchild.

(Re)Producing Your Produce
To correctly proportion the banana and apple in this photo, compare the width of the apple to the length of the banana.

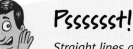

Pssssst!

Straight lines are easier to figure out than curved lines. Curves have a million ways they can go, from this:

to this:

and everything in between.
Straight lines are, well, straight. Faces are made up of curves, so there is more room for error. At various times throughout this book I'm going to have you draw lines to visually clarify what is happening.

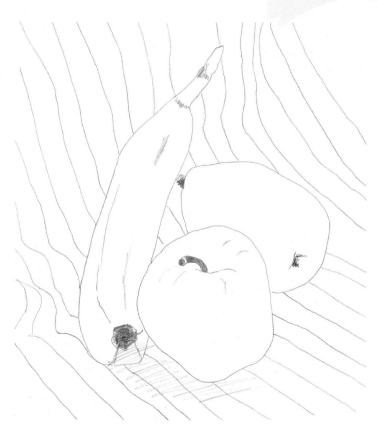

Drawing the Image
Now that you've figured out the proportions of the fruit, you can draw the image. Just sketch at first, then measure to make sure you've scaled one piece of fruit to the other. Remember, we're looking at a comparison system. Compared to the width of the apple, the banana is about twice as long.

Baselines

A baseline is anything we use for comparison purposes. A ruler is a baseline; that is, we compare things to the ruler to determine the length of an object. A meter is a baseline. The scale found on the bottom of maps is a baseline. We can use any object in a photo as a baseline and compare it to something else in the photo.

There are several ways to begin your drawing other than to just dive right in and sketch. Assuming you want to draw the exact size as your photo, you can measure proportions using just a scrap of paper. Measure the eye on the photo, then compare it against your drawing. Measure the nose on the photo and check it against your drawing. Simple.

There are also ways to adjust your drawing to be larger or smaller than the photo. Let's use the baseline concept for this first method of measuring our drawing. I'm going to draw slightly smaller than the photo.

Step 1: Select the Baseline of the Photo
In this example, we'll use the length of the eye. Mark the width of the eye on the photo using a piece of paper. Mark your paper "photograph" for the eye measurement on the photo.

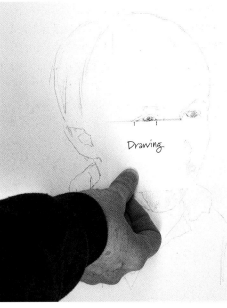

Step 2: Mark the Baseline of the Sketch
Measure the same feature on your sketch. Mark the paper "drawing" for the eye measurement on your sketch. You've created a baseline (the length of the eye) with which you'll be able to compare anything in your sketch. Use the "photograph" side for measuring the photo, and the "drawing" side to measure your drawing.

Don't Go Eraser Crazy!

Don't go into an eraser frenzy. What if the nose is too long, but the shape of the nose is correct? Before you erase the feature, sketch it in the correct location, using your previous work as a guide.

Step 3: Check the Nose Length
Use the "photograph" side of your slip of paper to compare the length of the eye to the length of the nose. When I do this, I discover that the nose is slightly longer than the width of the eye in the photograph.

Step 4: Compare It to the Sketch
I have discovered that the width of the eye on the photograph is about the same as the length of the nose. Now I'll check my drawing using the "drawing" side of the paper. Oops! I've drawn the nose way too long! I'll need to shorten it to the correct length.

Baselines and Live Subjects

Let's take the baseline-sketch approach to drawing three-dimensional (live) subjects. A piece of paper is not as useful as the rigid pencil, but the concept is the same: We're comparing one feature or part of the child to another to determine how much longer (or shorter) that part might be. The tough part here is keeping the child still enough to both sketch and measure. Good luck. Assuming you've managed the impossible and have sketched the child, you'll want to double-check your proportions using the baseline technique.

Psssssst!

Measuring using your pencil requires a few tricks you might want to try:

- *Be sure to extend your arm fully. It's always the same length that way.*
- *Keep your pencil perpendicular to the subject. Angling your pencil creates distortion.*
- *Always close the same eye.*

1 Select the Baseline on the Child

Select a part of the face or body to use as your baseline. It should be a smaller section, such as the length of the head.

2 Measure the Baseline

Take a pencil and extend your arm straight out in front of you. Close one eye. Use the tip of the pencil to mark the start of the baseline (in this case, the top of the head) and your thumb to mark the bottom.

❸ Compare the Baseline

Now compare the baseline to the rest of the body. In this illustration, the body has about seven heads in it. Check your sketch of the child. Have you drawn correct proportions?

Confession

I draw first and use the measuring system at the end or midway through to check how well I've scaled the drawing. It's faster than measuring ahead of time, and it trains my eye to pay attention to scale.

Using a Proportional Divider

Proportional dividers can save a few steps, but are expensive. However, they last a lifetime. They are designed so that once you set the proportion, you can measure everything on the photo and scale it to your drawing.

On one side of the divider is a wheel that slides the divider up and down to increase or decrease the scale. If the wheel is in the middle of the divider, you are drawing the same size as the photo. The more you move the wheel toward one side or the other, the greater the scale. On some dividers, there is a second wheel that locks the scale in place so that when you open it to measure, for example, an eye on the photo, the other side scales it to your drawing.

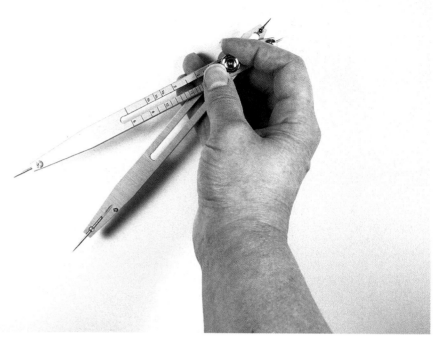

Proportional Divider
We need a few tools to help us see the correct proportions on a face. One tool is a ruler or straightedge. We're not measuring so much as using the line drawn by a ruler to provide reference points. The other tool is a proportional divider.

Step 1: Select a Feature to Set the Scale
Use the width of the eye again. Open the proportional divider so that one side measures the eye on the photo. The other side will be used to measure the eye on the sketch.

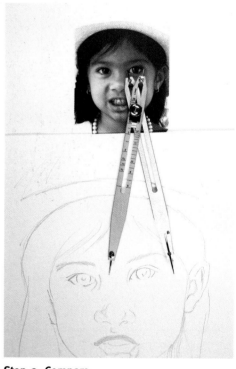

Step 2: Compare
Comparing the proportional divider to my sketch, I find it is too large. I need to move the wheel more toward the center.

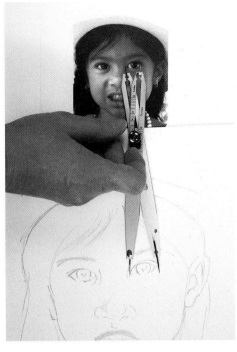

Step 3: Check Again
Go back to the eye on the photograph. Check
again and then compare it to your drawing.
When the eyes are set, tighten the divider.

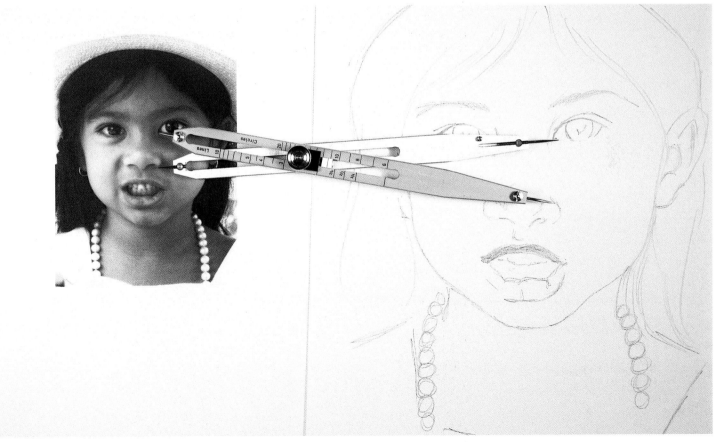

Step 4: Ready to Roll!
At this point, anything you measure on the photo with one side of the divid-
er will correctly check the proportion of your drawing. You're in business!

Creating a Grid

A classic way to draw something with correct proportion is to create a grid and place it over your photo, then draw a grid on your paper. Let's explore different ways to make a reusable grid.

Computer Grid

Create a 1" (3cm) grid on your computer, then print it on clear acetate designed for a printer. (Hint: Be sure you buy the correct acetate for your printer type.) You can also draw a grid on a piece of paper and copy it onto acetate designed for use with a copier machine.

Low-Tech Grid

Using a ruler and a pen designed to mark on acetate (such as an ultrafine felt-tip marker), you can create a reusable grid. Any piece of acetate will do, both clear cover stock or sheet protector work well.

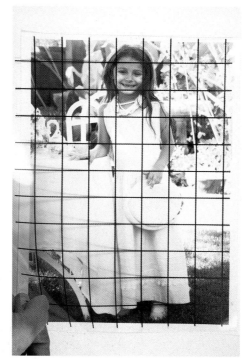

Make a Grid on Your Computer
There are a lot of programs you can use to make a simple grid on your computer. You can lay the grid right over your photo.

Draw Your Own Grid
If you prefer to keep it low-tech, a ruler, a felt-tip marker and a piece of acetate work very well.

Pssssst!

Drawing grid lines on your paper and then erasing them is a pain in the rear. A lightbox (or window on a sunny day), can be used instead. Place the grid on the lightbox, tape it down, then place your paper over the grid. You can see the grid through the paper and there's no erasing later.

Using a Grid

Draw a grid on a blank piece of paper. If you place a 1" grid on your photo and draw 1" (3cm) squares on your paper, you will draw the same size as the photo. If you draw a 1" grid on the photo and a 2" (5cm) grid on your piece of paper, you'll enlarge your drawing to twice the size of the photo. If you draw a 1" grid on your photo and ½" (1cm) grid squares on your paper, the drawing will be half as large. You get the idea. You can either use one of your own pictures or base your drawing on the grid photo on the previous page.

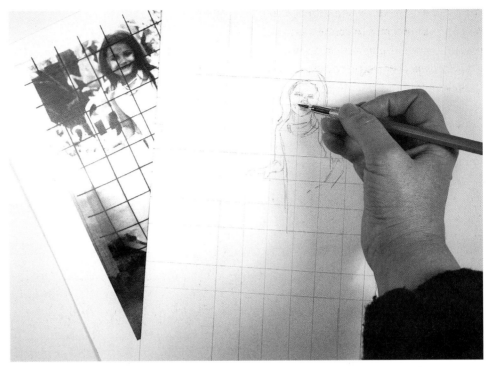

Number Your Grid Paper
You may get confused as to exactly where you are in your drawing compared to the photograph. To help you keep track of which square you're working in, number your grid on the photograph across the top and down the side, then do the same on your drawing.

When Less Is More

Grids, proportional dividers and slips of paper are all useful tools for drawing the correct proportions of the face. Sometimes, however, just a simple line will do. We talked earlier in the chapter about the power of a line. It gives the eye a concrete reference point. Sometimes you just need that little boost to see a subtle problem in your drawing.

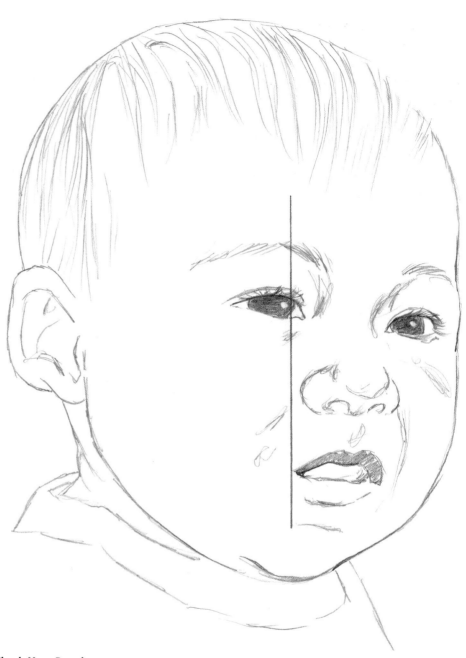

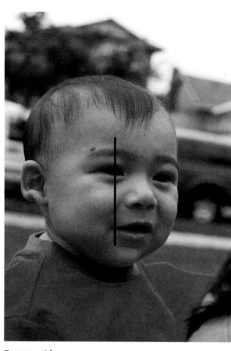

Draw a Line
A subtle error will jump out at you if you simply apply a horizontal or vertical line. Here a line is drawn on the photo of Daniel Deffee that goes from the edge of the mouth to the outside edge of the iris. These two points line up.

Check Your Drawing
When I apply the same line to my drawing, I can see that the width of the mouth is a bit off. This error is made clear by checking with a line. Now that I have the correct location, using the line, I can make the mouth the correct width. This technique is often referred to (by artsy types) as optical indexing.

Psssssst!

A straight line is an artist's best friend. It provides a concrete reference point that assists our eyes in recognizing even the most subtle angles of our subject.

Proportions Change

Because proportions are essentially comparisons, they can change. The proportions of the face change with age. The baby's face is wider, with most of the head above the eyes. The nose is short, and the eyes are wide set and large in the face. The lips are full, but small in the face. Similarly, a face turns and the angle from which you view it changes, so do its proportions according to your view.

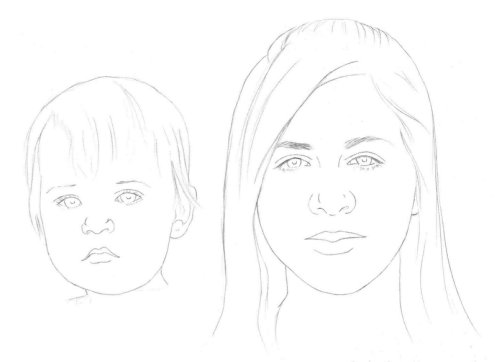

Proportions Change With Age
In the drawing above, compare the proportion of the baby's face to that of the twelve-year-old girl. Can you see the difference in proportion?

Proportions Change With Viewing Angles
Look again at the proportions of the face as it turns. Notice that one eye gets smaller, the tip of the nose moves from the center of the face, and the mouth is asymmetrical. One ear disappears, while the other changes shape, and the width of the face changes.

The Three-Quarter Turned Face

Many photos of children are captured as a three-quarter turned face. It makes for interesting angles, a lot of great lighting and exciting shading.

The biggest problem is that there are few hard-and-fast rules that will help you master the techniques for drawing such a face. There are simply too many variables. I'm going to come right out and say it: You're going to have to pay close attention to your subject. The eyes won't be the same size, the lips will be unequal, the nostrils won't match, ears, hair, forehead . . . sigh. Now factor in all the angles required to master drawing the range from a baby to a teenager, and you might need an entire library of rules.

Now, before you throw this book across the floor because you've realized that that's exactly the angle you're trying to draw, I'll offer a suggestion or two.

Three-Quarter Turned Faces
Four faces, four ages, four sets of drawing challenges. To achieve correct proportions, you must pay very close attention to all these different angles.

Nicholas Gonzales

Serena Heppes

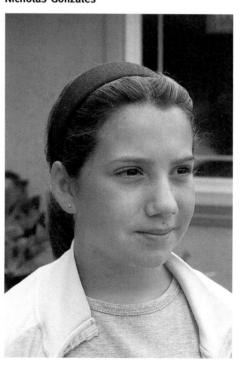

Taylor Gonzales

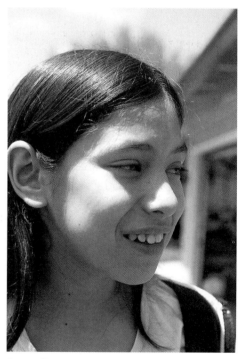

Casey Castro

Keep It Curved

Almost every art book has an illustration that demonstrates how the face is a round shape. The authors note that by observing this shape, the budding artist will correctly render the facial proportions. Unfortunately, the single most difficult shape to draw is a curve. The slightest deviation can alter the image. Eyes, noses, lips, ears—in fact, most of the face has curved and rounded shapes, and to create a likeness, these difficult curved shapes must be rendered perfectly.

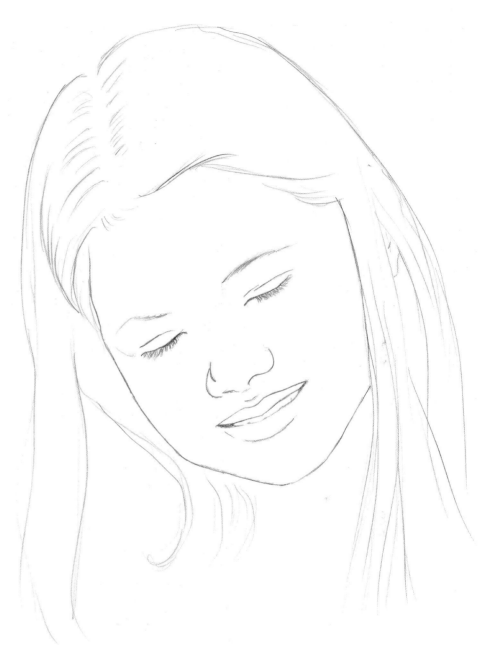

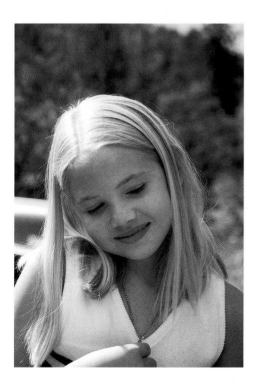

Remember the Curves
There are several simple techniques that will help us accurately render a curve, in addition to the measuring techniques already covered in the chapter.

Box and Measure

A useful technique for finding the curve of the cheek in a three-quarter profile is to box it in and measure it. Draw a vertical line down from the cheek and connect it to a horizontal line drawn from the chin. You can measure the width of the eye and compare it to your box. In this case, the width of the eye is repeated about four and one-half times down to the bottom of the chin and about four eyes over. On the photo you're using, you'd measure x number of eyes down and x number of eyes over.

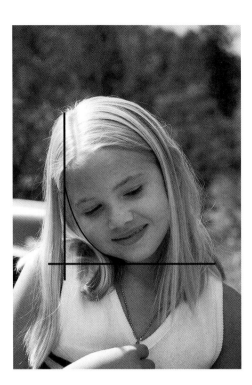

Box and Measure
The curve of the cheek is easier to see when compared to the straight lines.

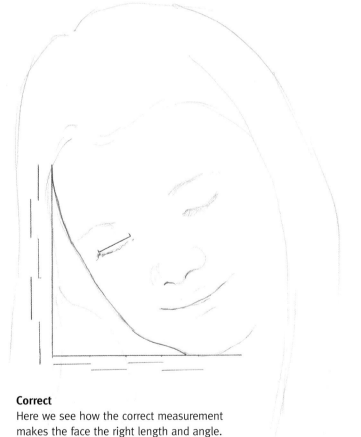

Correct
Here we see how the correct measurement makes the face the right length and angle.

Incorrect
If you draw the wrong angle, the measurements will also be incorrect, and your drawing will be off.

Create Negative Space

Another way to see a curve is to create "negative space," which is the area around a "positive space." If you're drawing your hand, your fingers and palm form the positive, and the spaces between the fingers and around your hand form the negative. If the negative space is incorrect, the hand will be incorrect. By placing straight lines and boxing in the shape you want to draw, it is often easier to see the curve in the space outside the cheek.

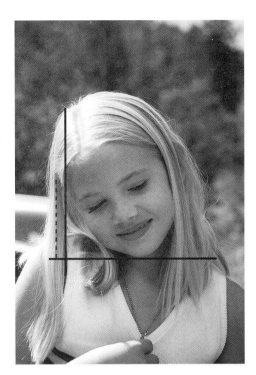

Create Negative Space

If I box in the side of the face, I create a shape that consists of the negative space. My goal will be to make sure my drawing matches this shape.

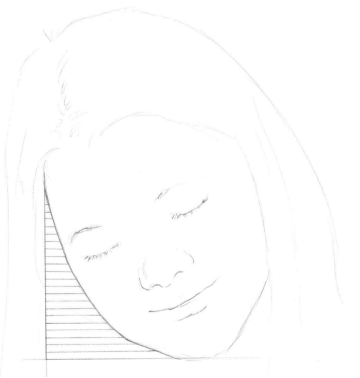

Correct
Here I've correctly duplicated the negative space; therefore, my drawing of the cheek is correctly angled and shaped.

Incorrect
Compare the shape here to the correct shape. It's easier to see that the drawing is off because I'm drawing just shapes, not the darling face of the precious child.

Facial Foreshortening

The same challenges found in drawing the three-quarter turned face are present in drawing a child looking up or down.

The main issue we encounter is foreshortening, which is the illusion of depth created by the apparent distortion of the object—in this case, the face. As the face looks up or down, our eyes see the illusion of parts of the face becoming longer or shorter.

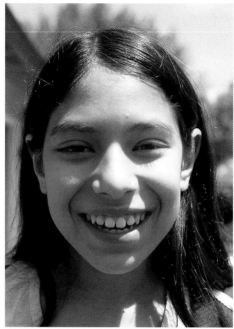

The Level Face
In this level view of the face, notice the location of the eyes and the distance to the top of the head and the chin.

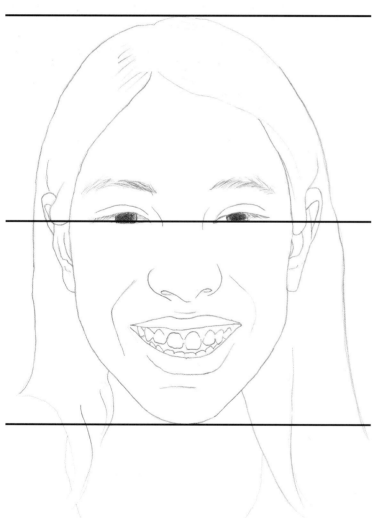

Pssssst

If you're uncertain whether the child is looking slightly upward or downward, check the location of the ears. The lower the ears are on the face, the more the face is looking up. The higher the ears, the more the face is looking down.

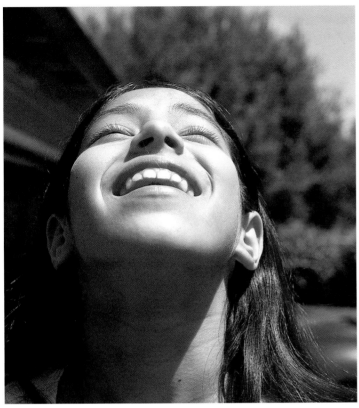

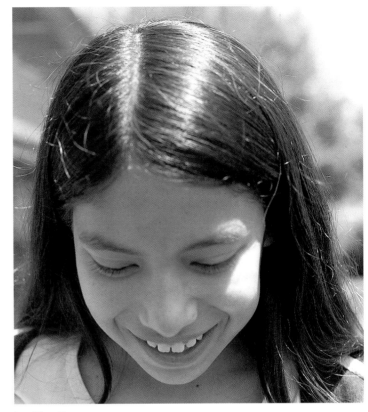

Looking Up
As the child looks up, the lower face is longer and the upper face is shorter.

Looking Down
As the child looks down, the lower face is shorter and the upper face is longer.

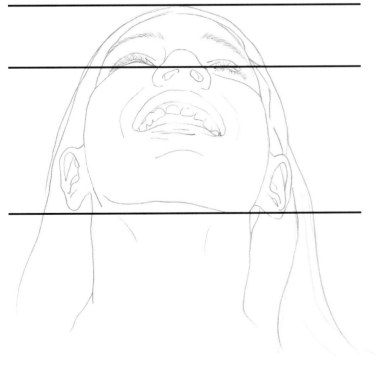

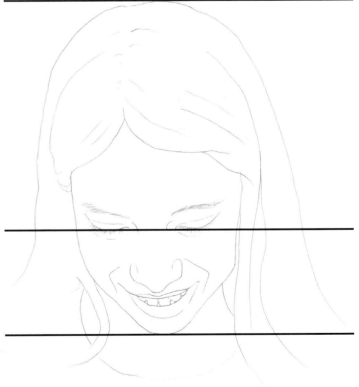

Your Turn

Draw the child below using one of the methods introduced earlier in the chapter. You can sketch and measure; grid, box in and measure; box in and check negative space; or use a proportional divider if you have one. Concentrate on getting the proportions correct. We'll work on shading and individual features later.

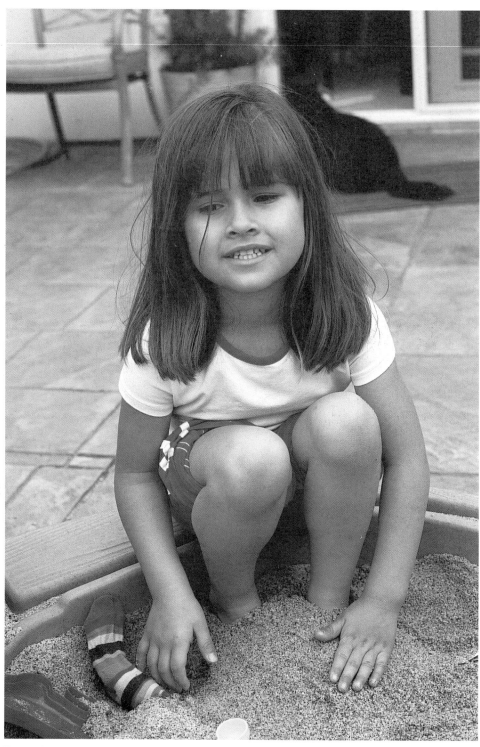

Renee Ortega
Try to sketch her first without worrying about facial and clothing details. Try to make your overall proportions correct. Measure or sketch in some guidelines to observe any curved shapes.

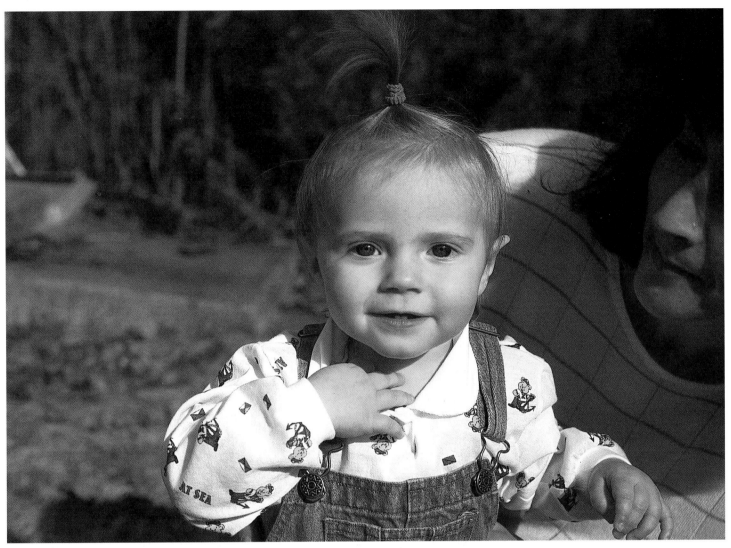

Shilo Stuart
Useful techniques to counter foreshortening
include lining up the facial features, using a
baseline to check scale, and checking curves
to make sure they are balanced.

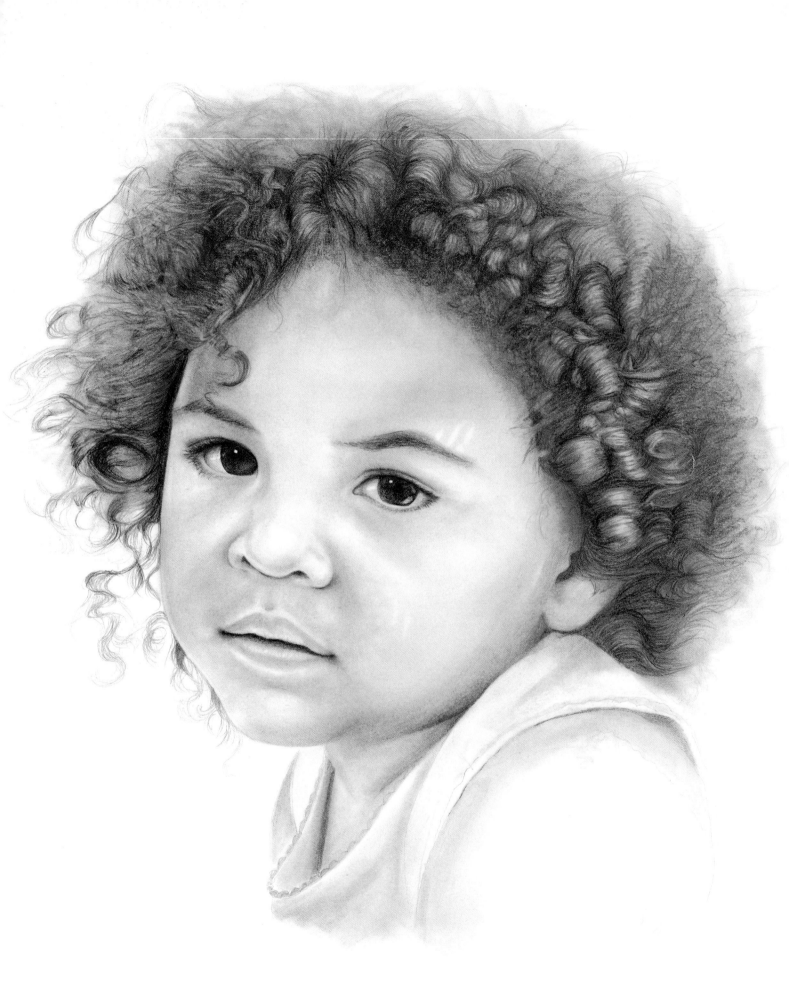

Face-to-Face

I n the previous chapter, we worked on mastering facial proportions. Now we will work on drawing the facial features of a child. One of the biggest challenges in making a child look the correct age is to accurately represent the shape of the individual features. We'll work on overcoming drawing what we *think* we see compared to drawing what is actually present.

In this chapter, you'll learn some rules of thumb for drawing facial features such as eyes, nose, ears, hair, lips and smiles. We'll use a generic child (not your own). It's up to you to work on the subtle shapes of the child you choose to draw.

Small Stuff
This darling little girl was a wonderful subject for us. We drew her eyes with a circle template to make sure they were round. We also paid close attention to the amount and shape of the whites of her eyes.

CHIARA MASK
Graphite on smooth bristol board
16" × 13" (41cm × 33cm)

Drawing Eyes

Once I have the general facial proportions, I tend to start drawing the eyes. The eyes have so much character. Let's look at some general principles that apply to eyes.

Shapes of the Eye

Iris

The iris, or colored part of the eye, is round when viewed from the front. Remember: round, round, round. Don't try to fudge it. Use your circle template to draw a round circle.

Pupil

The pupil of the eye is in the center of the iris when viewed from the front. Look at your circle template. The circle has four little marks on the top, bottom and two sides. If you connect these four marks, you have the exact center of the circle. You can now select a second smaller circle, align the same marks, and eureka! You've created a centered pupil.

Now let's talk about the size of the pupil. I know, I know, you have a photo and it shows the pupil size. Ignore that. You'll want to draw a large pupil. Large pupils make the drawing more likable. Small pupils work the reverse and make your drawing less attractive. Big = good. Small = bad. Pretty easy.

What Color are Your Eyes?

We're not leaving pupils just yet. In addition to placing the pupil in the right spot and at the right size, the pupil must be black. I don't mean a soft, whispery gray- ish black. I mean black. Can't-push-on-the-pencil-any-harder black. It has to be one of the blackest blacks on your paper because contrast is important. Initially we'll be concerned with the contrast between the pupil and the iris, because it's that contrast that tells the viewer the eye color. We can't break out our colored pencils and scribble in blue to make blue eyes . . . well, not in this book, because we're mastering the pencil. So, when we see a black-and-white photo, we subconsciously compare the black of the pupil to the value (lightness or darkness) of the iris. Dark-brown eyes make it difficult, or even impossible, to see a separate pupil.

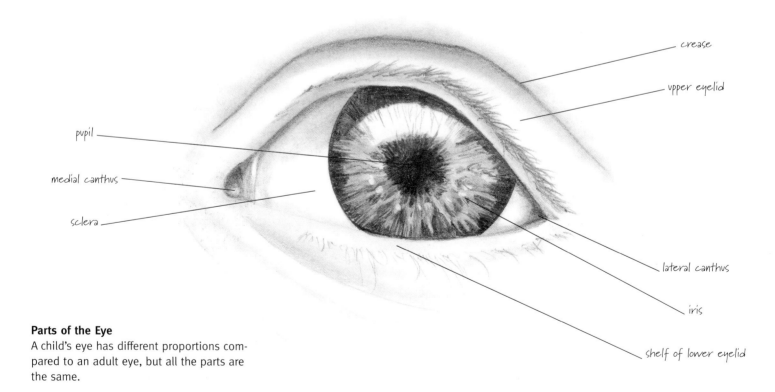

Parts of the Eye
A child's eye has different proportions compared to an adult eye, but all the parts are the same.

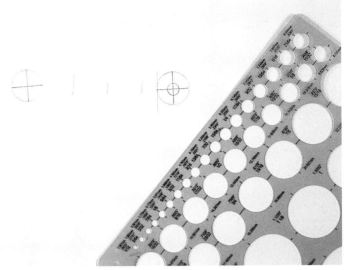

Center the Pupil
A circle template helps ensure that your pupil is properly centered in the iris when you're looking at your subject from the front.

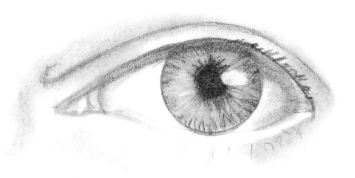

light blue or green [lightest]

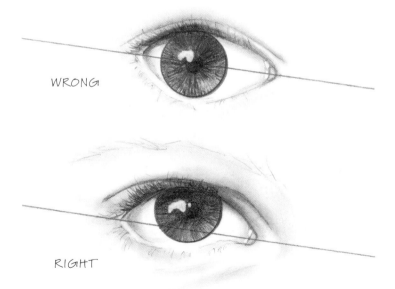

WRONG

RIGHT

No Footballs
An eye isn't shaped like a football. If you draw a line from inside corner to inside corner, most of the curve of the lid should be on the top.

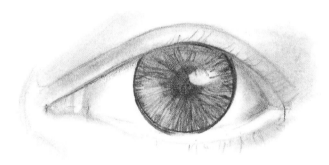

blue, green or hazel [middle values]

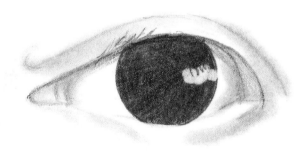

dark brown [darkest]

Eye Color
You can determine eye color by how light or dark the iris is in comparison to the pupil.

Eye Shapes and Variations

Remember: Everyone's iris is round when viewed from the front. Some variations can occur that make an eye distinctive such as the lids or the shape of the whites of the eyes.

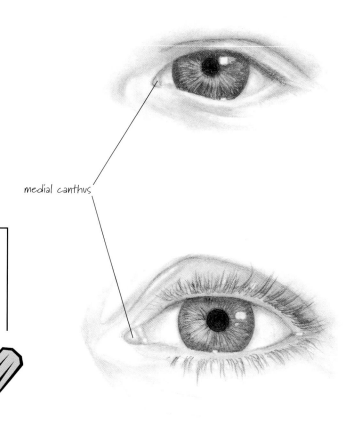

medial canthus

The Doohickey (or Medial Canthus)

My students give me a hard time because I call the inside corner of the eye the doohickey. I know, I know . . . it's a medial canthus, but if I start rambling on about a medial canthus, will you care? Nope. But a doohickey, now there's something we can really get our minds around. It's located on the inside of the eye nearest the nose. It's usually pinkish in color and triangular in shape. It's one of the areas that changes with age. Babies have tiny doohickeys. As we get older, the shape changes, with the bottom growing flatter and longer in shape.

Whites of the Eyes

The amount of white in the eye makes a huge difference. The eye of a child is almost all iris, with comparatively little white. Can you pick out the child's eye versus the adult eye? The iris remains about the same size, but as we grow older, our eyes grow larger, creating more white. In addition, the inside corner, called the medial canthus, grows longer and larger with age.

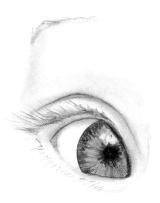

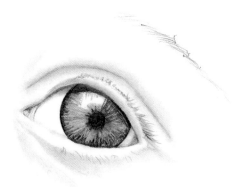

Eyebrows

A child's eyebrows are usually thin and high on the face. You need to keep your pencil sharp to create these fine lines. If the eyebrow is fuller and thicker, just add more lines. Don't let your pencil get dull!

Eyes at Different Angles

We've examined eyes from the front, now let's look at a few different angles. One common mistake is to change the eyes drastically because they are in profile. Think about it: Your eyes don't grow or change just because your head turns. The eye in profile is half the eye (plus a smidge) when viewed from the front. I add a smidge because of the cornea, the clear lens that covers the iris and makes the eye more rounded in profile. Also, the bottom of the eye doesn't sneak up to create a sideways football, so avoid that mistake.

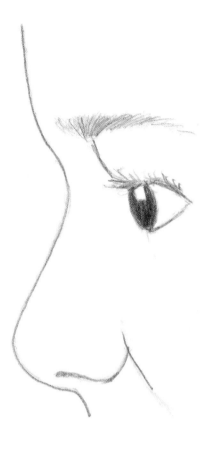

Common Errors in a Profile Eye
Two common problems are the size of the eye and the location of the corner of the eye.

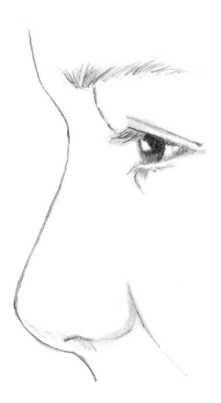

Correct!
This eye is drawn correctly from the side, because the white of the eye is smaller and the corner is lower.

Drawing the Eye in Profile

Here's an easy way to keep the eyes in profile correct.

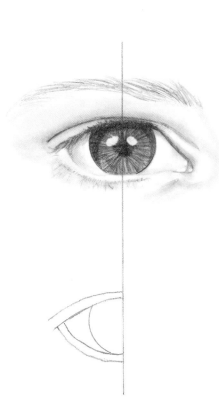

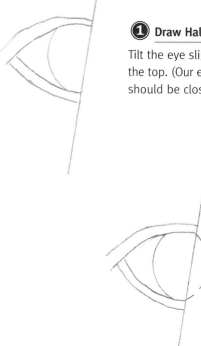

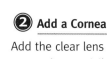

① Draw Half an Eye

Tilt the eye slightly so that the bottom is not perfectly level with the top. (Our eyes don't tend to be totally flat.) The bottom eyelid should be closer to the face than the top eyelid.

② Add a Cornea

Add the clear lens (cornea) over the iris. The cornea is not visible from the front view of your eye.

Half an Eye

Another way to look at the profile eye is to understand that we're looking at half an eye.

In profile, we see the outside edge of the eye to the center of the iris.

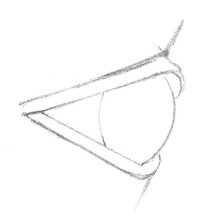

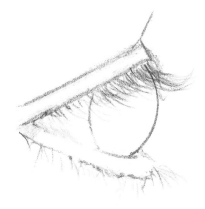

③ Build the Eye Socket

The eye sits inside the socket. Remember to wrap the lower eyelid around the eye. Eyelids appear straighter in profile.

④ Add Eyelashes

The lower eyelashes grow outward from the outer part of the lower lid. The upper lashes grow down and forward. Now that you've added the eyelashes, notice how little you can see of the white of the eye.

Shaping the White of the Eye

As the head tilts in different directions, the shape of the white of the eye gets larger or smaller. One helpful secret is to trace the shape of the white of the eye, then trace the shape of your drawing of the white of the eye, then compare the two shapes side by side. The subtle differences in the shape become more apparent. This is because the tracing paper removes all the unnecessary details that clutter up the brain, helping you to focus on one shape.

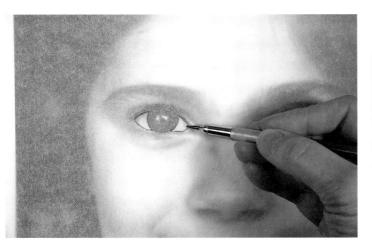

① Trace the Photo

Trace the white of the eye using tracing paper.

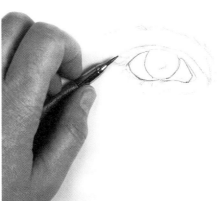

② Trace the Drawing

Trace the same shape from your drawing.

③ Compare

It's easy to see that I haven't drawn the eyes correctly when I see the two shapes separately. I'll need to correct my drawing to make it better.

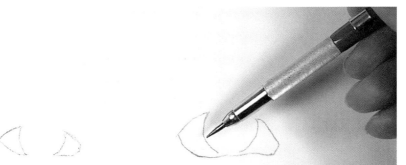

photo

my sketch

Practice Drawing Eyes

Ready to give it a go? Here's a lovely pair of eyes, let's draw them. Follow along as I complete one of the eyes with you. Then, follow the steps again to complete the second eye on your own.

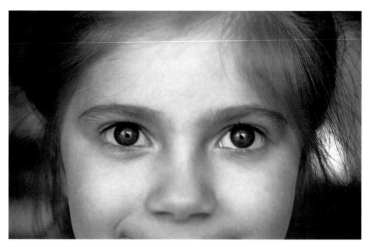

Reference Photo

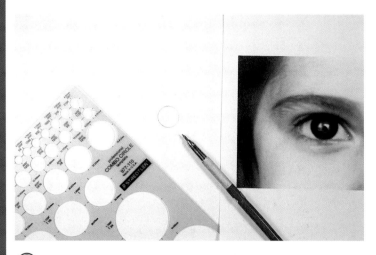

① Draw a Circle

It is logical to start with the iris because it's easy to explain. Using your circle template, draw a circle. Make it large enough to work with.

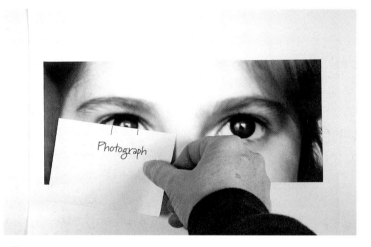

② Measure the Iris

Using a small slip of paper, measure the width of the iris on the photo. (See "Baselines" on page 55.)

③ Measure Placement for the Second Iris

Using the measurement from the first iris, measure to the second iris. You should find it is three and one-half irises over.

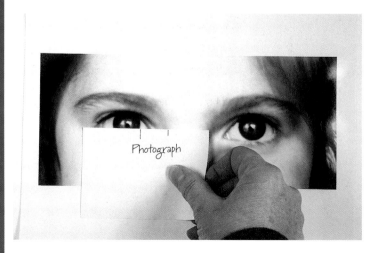

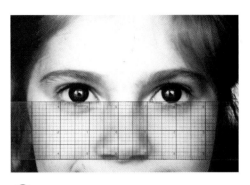

④ Repeat on Your Drawing

Make the same measurement on your paper. Be sure to measure the size of the iris you drew and use that measurement, not the measurement you took from the photo.

⑤ Find the Center

Using your circle template, find the center of both circles. Then select the correct pupil size. Remember that big is better than small!

⑥ Straight or Angled?

Eyes may be level or may tilt up or down in the outside corner. It's difficult to see the subtle tilt of the eye without help. Think back to the chapter on proportion (page 53) and place a ruler on the photo to create concrete reference points (lines).

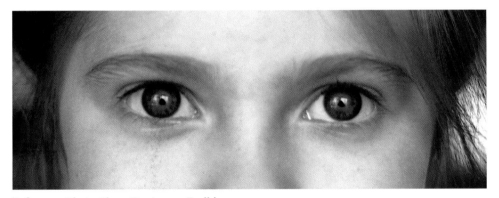

Reference Photo Close-Up: Lower Eyelids
This is an area where a very common mistake is made. Notice that the lower lid forms a shelf. The shelf is widest toward the outside corner and disappears toward the inside corner.

⑦ Draw Upper Eyelids

Draw the upper lid. Pay close attention to the shape and where the lid goes over the iris.

⑧ Draw the Lower Eyelids

It will take two lines to create the shelf of the lower lid; one line to indicate where the lid touches the eye and one line to show the outer part of the lid where the eyelashes are found.

Erase all the guide marks and lines except for those within the iris.

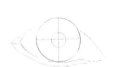 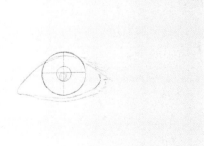

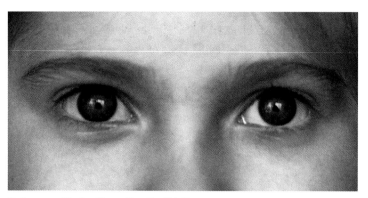

Reference Photo Close-Up: Eyelid Crease

The location of the crease of the lid, formed by the eye when open, varies from child to child. An average eye has a crease that follows the upper lid. In some children, the crease is very high and forms heavy lids. In other cases, there isn't a crease at all. Eyes that don't have creases are known as overhanging lids. The eyes we're working with have average eyelid creases.

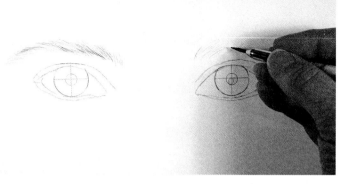

⑨ Draw the Eyelid Creases and Eyebrows

Note the location of the lid creases and place them on your drawing.

Eyebrows are made up of short, fine lines that grow away from the center of the face and taper at the ends. Lift your pencil at the end of the stroke to create a line that tapers.

⑩ Start Shading

Establish the darkest-dark, the pupil, using a 6B pencil. Place the circle template over the iris and darken the circle. Create short, dark lines going inward toward the pupil. If you are drawing dark-brown eyes, you won't have to worry about this part—the entire iris is dark.

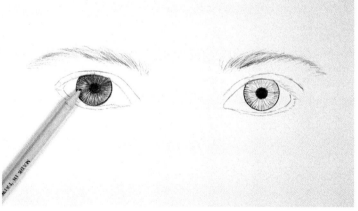

⑪ Develop the Iris

The iris has a linear quality that fans out from the pupil. Shade in the iris by drawing thin lines outward from the center of the eye. Use your paper stump to blend the lines.

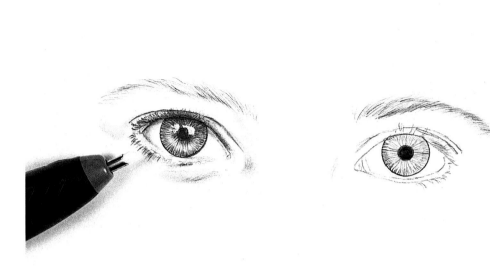

⑫ Add Shading; Leave Whites White

Find the areas of the eye that are white. This will be the part of the paper you leave white. That means that unless it is white, everything else (and I do mean everything) must have some shading on it. Use your pencil and paper stump to darken the rest of the drawing. Think of it as a test of lights and darks, not of shading the eye.

Using your electric eraser, lift out any highlights you may have shaded over or not yet included. Lift out the shading on a diagonal from the highlight (on the lower left side of the iris) to create the cornea. Using your kneaded eraser to lift out (tapping gently once or twice) the area diagonally across from your highlight will create the appearance of a lens.

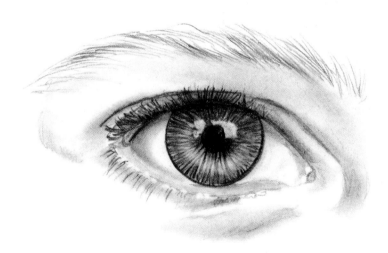

Drawing Glasses

Drawing glasses doesn't have to be a nightmare. Following are some ideas that will help you—and they're cheaper than buying your child contacts because you can't draw glasses.

① Sneaky Idea: Trace

If you are drawing a child who is looking directly at you, it can be difficult to make both sides even. Get one side the way you want it, then trace it on tracing paper.

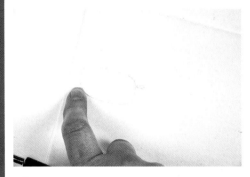

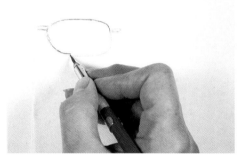

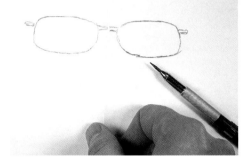

② Fold

Fold the tracing paper in half at the side of the glasses that form the nosepiece.

③ Trace Again

You can see through the tracing paper and hence see the side you've drawn. Trace it.

④ Open

Open your tracing paper. You have drawn matching sides.

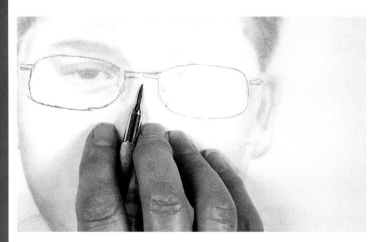

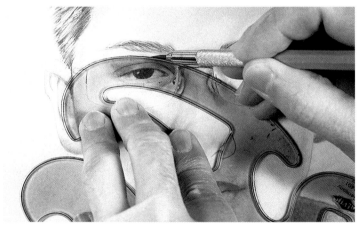

⑤ Trace Again

If you place the tracing paper facedown on your drawing, you can trace over the glasses you've sketched and the graphite will transfer to your drawing.

⑥ Add Final Touches With a French Curve

Glasses are mechanical items; that is, they have a man-made, symmetrical appearance. To achieve this look, you'll need to use French curves. Which French curve you choose depends on the shape of the glasses. Most French curves come in a package of three of the most common curved shapes. The different curves may be placed over the glasses in the photo to determine the closest match. I sketch the glasses first, then use the French curve to clean up my edges and curves.

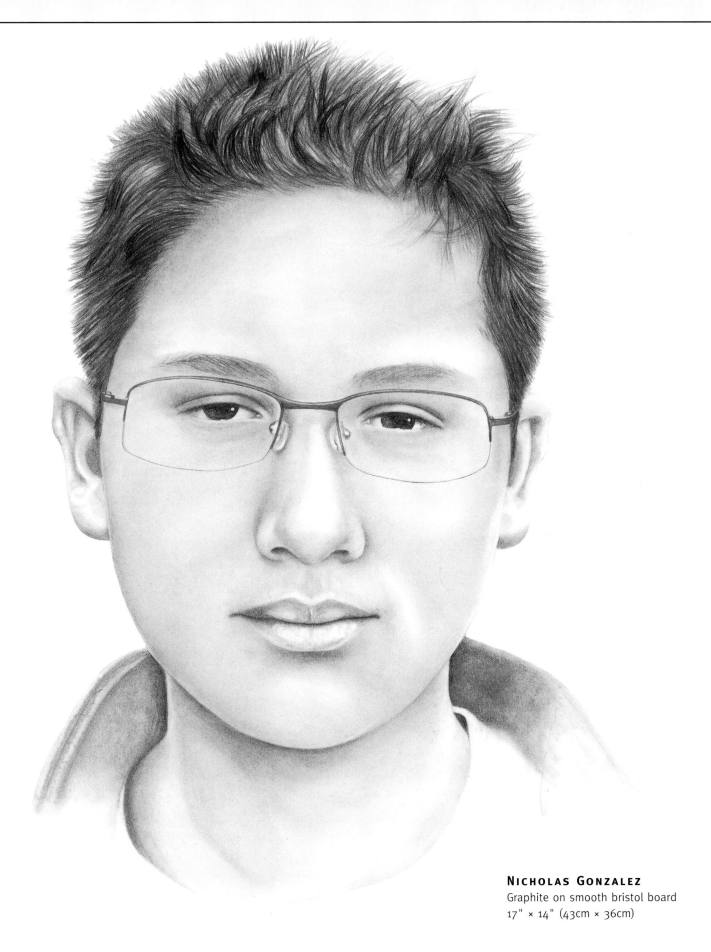

NICHOLAS GONZALEZ
Graphite on smooth bristol board
17" × 14" (43cm × 36cm)

The Nose

Don't fear drawing *the nose*.

Many folks are spooked when it comes to drawing a nose. I've mentioned drawing the nose throughout the book, now I'll show you some helpful techniques to draw the nose correctly.

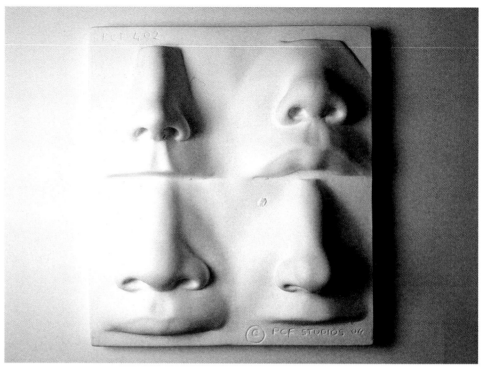

Practice Casts
As you're learning how to proportion and shade the facial features, you may want to invest in some practice drawing casts. Notice how lighting changes the appearance of the nose.

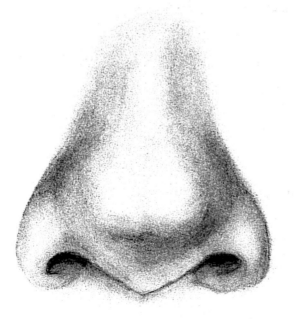

The Button Nose
The younger the child, the shorter the nose and the less shading that is required to create the shape. The important parts of the nose are the shapes of the nostrils, the tip and the wings (see page 92).

Nose Details to Watch

Once again, make sure the nose is the correct length and width before starting. Below are the parts of the nose that I want you to pay close attention to in the child that you're drawing.

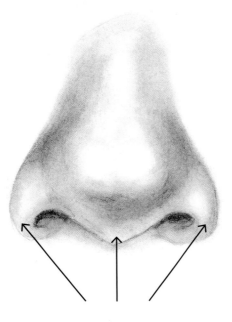

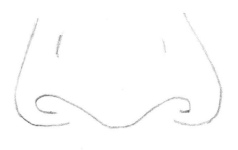

Details
There is an area of skin between the outside of the nostril and the wing and another between the nostrils.

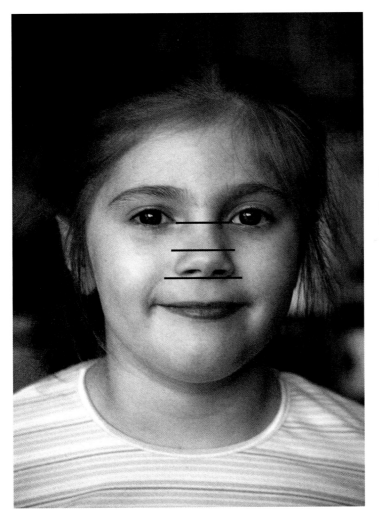

Wings
The wings of the nose on a child's face are often half the distance between the bottom of the eye and the bottom of the nose.

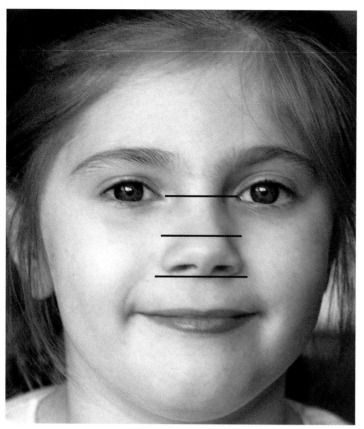

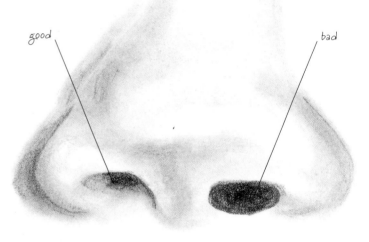

Find the Highlight

In chapter three we worked on the shading process. Now we'll start to apply those lessons. First, find the lightest part of the nose. Keep it as light as the paper (meaning everything else must be darker than the highlight).

Watch Your Darks

Although the nostril looks like a round, dark hole, don't darken it as a solid, black circle. Color the top of the nostril the darkest and gradually get lighter toward the bottom.

Remove Lines

Although you'll draw lines to show where the outside of the wings will be, you'll need to blend the lines so that they don't show.

Nose Technique: Box It In

Draw a box to contain the nose. Draw it the correct size and place it in the proper area on your drawing. Trust the size of the box. Many of my students figure the nose can't possibly be as large as the box they've drawn, so even though the box is correct, they still draw the nose too small. This is because the line drawing of a nose appears much broader than the finished drawing. After the shading is added, the nose becomes more narrow. Let's practice.

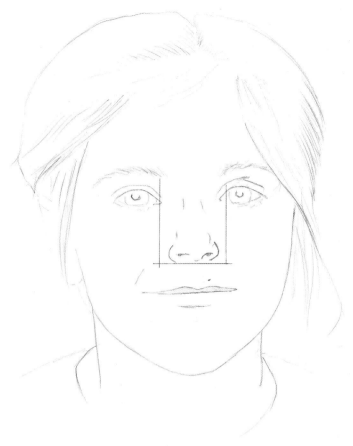

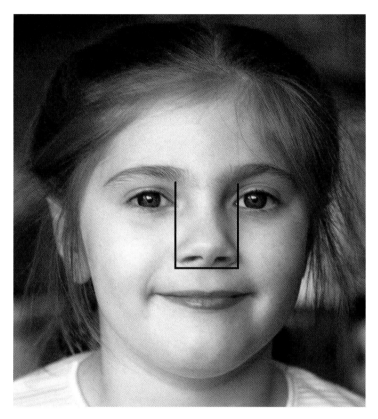

Reference Photo
Create a box around the nose to help draw it proportionally correct.

❶ Create a Roundish Shape

Use a lot of lines. My example is more oval, but will become round.

❷ Add Two More Roundish Shapes

Your drawing should look a bit like a Volkswagen with big tires.

❸ Add Nostrils

Weave a pair of nostrils through the round shape. Think of the letter *M* with very rounded ends.

④ Move up to the Forehead

Create the shape of the part of the nose that continues up to the forehead. I've used a series of scribbles that curve.

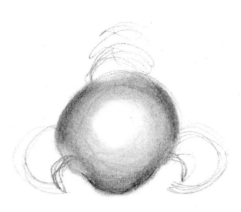

⑤ Begin Smudging

Using your paper stump, smudge in the same circular shape that you originally sketched. Leave the center white to create the highlight.

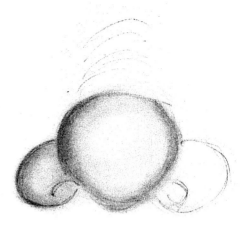

⑥ Smudge the Wings

Move down to the wings of the nostrils. Smudge in the same circular strokes used to create the wings.

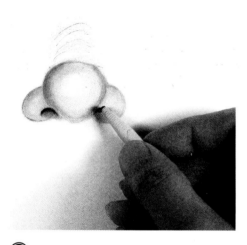

⑦ Create the Nostrils

The nostrils here are round, although nostrils may be oval or somewhat triangular in shape. Younger children's nostrils tend to be rounder than adult noses, then develop as the child ages. Darken the top using a tortillion (above) or a soft-leaded pencil (2B–6B) and blend downward. Don't color the area totally black.

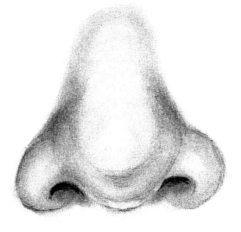

⑧ Back to Smudging

Blend the sides of the nose by smudging and using the rounded strokes you created as you worked your way up to the forehead. Notice how the nose has a rounded look due to the shading direction?

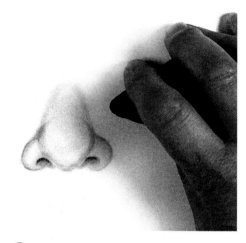

⑨ Smooth the Nose

Use your eraser if the nose looks a little too round at the tip. Erase the rounded top of the nose to remove some of the bulbous appearance, and add more dark to the top of the wings.

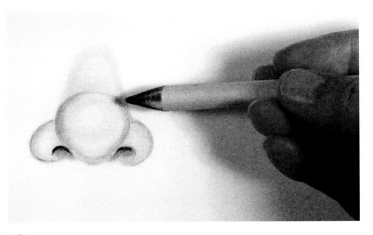

⑩ Make the Nose More Prominent

Add a bit of dark to the tip and move the shading in to make the nose appear more pointed and prominent. Do you see the hint of reflected light at the base of the nose?

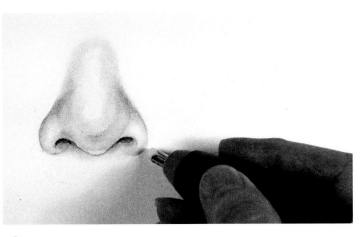

⑪ Flatten and Narrow the Base

Use your electric eraser to flatten and narrow the base of the nose by erasing the outside of the wings.

⑫ Refine the Nostrils

It is easy to refine the shape of the nostrils in these final stages. Change the rounded bottom of the nose by the nostril from a curve to more of a "V" shape to alter the appearance of the nose.

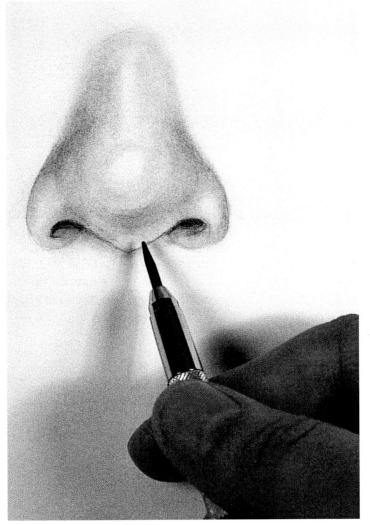

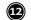

Ring Around the Nosy

The nose I've created is very round and bulbous at the tip and may not be exactly the shape you are seeking. You can alter the shape of the nose by moving lights and darks, or subtracting shadows.

The Nose in Profile

Children's noses in profile often turn up at the end. As they age, they turn a bit downward. The angle of the nose is important to get right. Capturing a child's likeness necessitates paying attention to the smallest details such as this.

The wings of the nostrils of an adult nose should appear above the columna (the column that divides the nostrils).

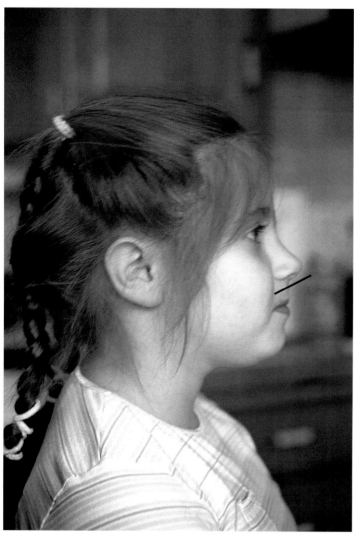

Children's Noses Turn Up in Profile
A single line drawn on the photo will help you see the correct angle.

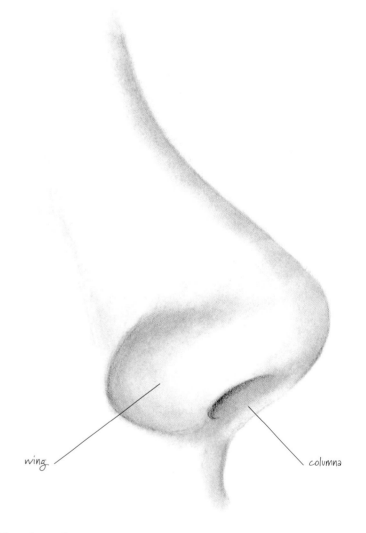

wing

columna

The Wings Should Appear Above the Columna
The wings are short, curved shapes that wrap around the nostril.

Nose Placement

The placement of the nose remains constant regardless of the angle from which it is viewed.

When we view the face from the front, the sides of the wings should line up with the inside corner of the eye.

Turning the face to profile doesn't move the nose. Notice that the back of the nose needs to be in front of the eye. One common problem I see in profile noses is that artists tend to place the back of the nose in line with the center of the eye. This makes the nose too large and is incorrect.

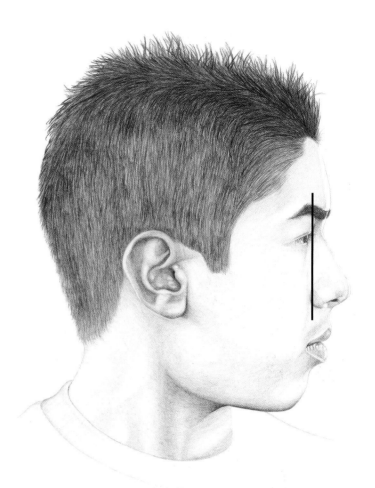

From the Side

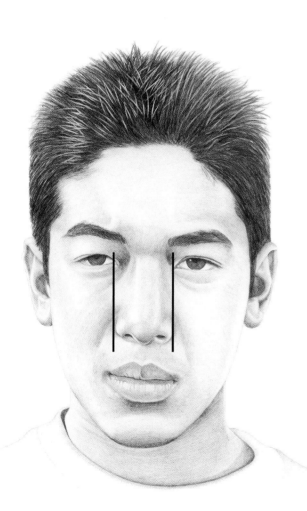

From the Front

The Lips

I'll confess that photographing lips proved to be one of the harder problems in constructing this book. Every time I brought out the camera, the kids would start grinning or giggling. We'll cover smiles in a later section (see "Drawing a Smile" on pages 98–99). Here we'll study the shapes and shading of the lips.

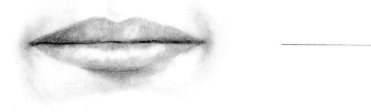

Lip Lines

The middle line of the lips (the part that opens to form the mouth) has one of several shapes. Pay attention to the shape of this line.

Often artists draw just a straight line, not noticing that the lip line dips, and has a bump or curves. If the middle line is incorrect, the upper and lower lips will be incorrect. Again, it's the tiniest details that make a drawing look right.

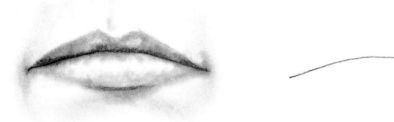

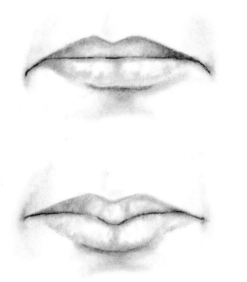

Shapes

The younger the child, the smaller (in width) the lips are on the face. As the adult teeth erupt, lips grow wider and often the small "bump" in the center is stretched out and flattened.

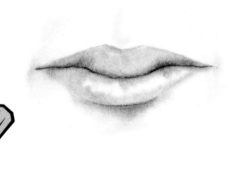

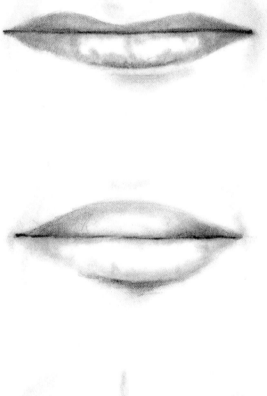

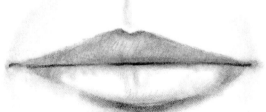

Upper and Lower Lips

The upper lip may have peaks that are pronounced, rounded, widespread, high, low or any combination of shapes. The lower lip usually has less variety, so observe its amount of fullness. These are children's lips (at left), but without anything to compare them to, they look like adult lips. Baby lips are the exception because they are smaller from side to side and fuller in the middle. They are often more curvy in the defining line between the upper and lower lip.

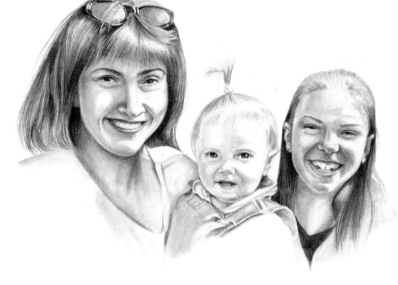

Lip Location

Notice the location of the lips, by age, compared to the location of the chin and nose.

 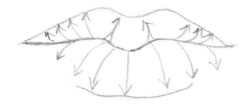

No Lines

Now for a *big* secret: There are no lines around the lips. You see the lips because they are usually darker or lighter than the skin around them. When you shade in, remove the lines. The only remaining line should be the part of the lips where the mouth opens. Lighten the line used to create the lips by tapping it gently with a kneaded eraser. Then shade the upper lip with a value that is (generally) darker than the lower lip. (Thinner lips are often uniform in color.)

Shading

When you draw the lips, you'll usually draw the lines that indicate where the lips are located.

How to Apply Shading

There are tiny linear lines in the lips. Your shading should overlay those lines. Remember shading the iris of the eyes (page 82)? We fanned lines out from the center (the pupil) so that the pencil lines mimicked the underlying eye structure. The same holds true for the lips.

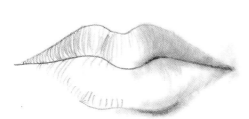

Blend

Once your pencil strokes indicate the shading direction, start blending. I've left large spaces between the strokes so that you can see what I'm doing. When I'm actually shading the lips, my linear pencil strokes are very tight with little or no white space between the strokes.

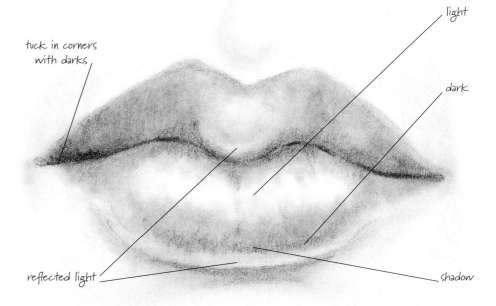

tuck in corners with darks

light

dark

reflected light

shadow

Full Lips

Children often have fuller, shinier lips than adults. To achieve this, think about what it takes to make something look round. The pattern is the same: light, dark, light, dark.

The Lips in Profile

Three common problems in drawing profile lips include length, shading and angle. Let's take a look at these issues.

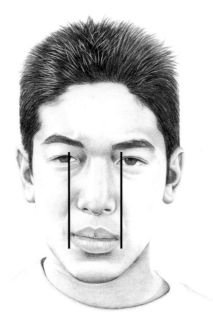

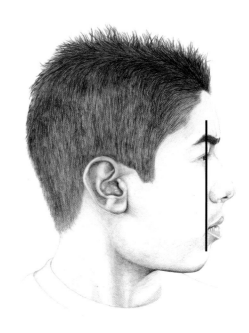

How Wide Is Your Mouth?
A child's mouth is smaller from side to side and grows wider as the adult teeth fill in.

Where Does It End?
In profile, the mouth should end long before you reach the eyes in young children. As the child grows older, the lip will be longer.

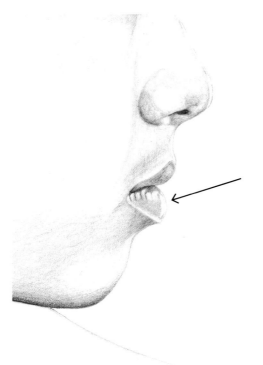

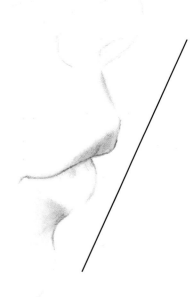

Round Lips
You'll want the lips to have a fullness, so be aware of the roundness of the lips.

Angled Lips
Generally, for both adults and children, the top lip sticks out a bit farther than the bottom lip. A quick application of a vertical ruler will help here.

Drawing a Smile

Smiles usually show off teeth (with the exception of babies, which usually display gums and perhaps drool). The toothy smiles of children are often half baby teeth, half adult teeth, missing or covered in braces. They almost always end up looking like a picket fence if not drawn carefully. Let's draw a mouth now.

① Use a Reference Photo for the Right Location and Shape

To ensure you draw the shape of the mouth correctly, draw a horizontal line on the photo just above the corner of the lip. Check to see if the corners of the mouth go up or down. Align the width of the mouth to the eyes. Double-check your drawing by measuring.

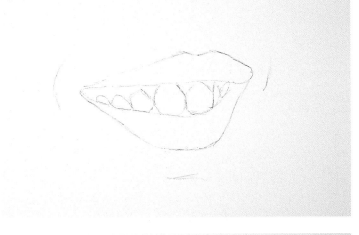

② Sketch the Mouth and Teeth

Sketch the mouth based on your measurements, then count the number of teeth you can actually see. Don't throw in a mess of teeth to fill the space. Observe which teeth are longer and larger and fill them in accordingly.

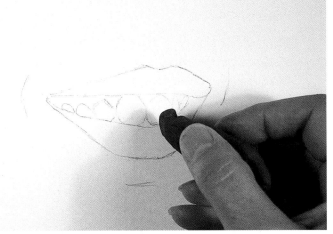

③ Erase!

Most of the time, the lines you've sketched for the teeth will be too dark. You want to imply the division between teeth, not perform a root canal with your pencils. Erase a portion of your lines and lighten, then lightly shade them in again. (If you're drawing widely gaping teeth, ignore this step.)

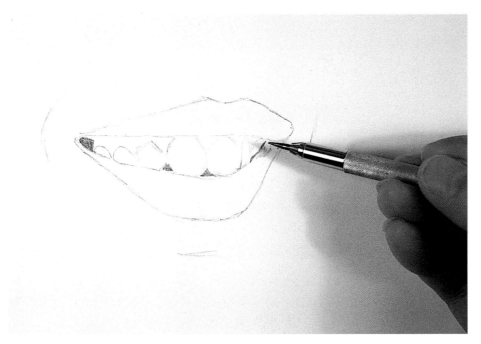

④ Add Shading

The values (relative lights and darks) around the teeth and lips tend to be very close, but they're not the same value or you wouldn't see where the gums end, where the lips begin or the roundness of the lips. If there is a shine on the lips, that will be the white of the paper. We need to place the darkest dark so we have a full range of values. Often the darkest area is in the corners of the mouth. By shading in this dark, you are starting to form the back rows of teeth.

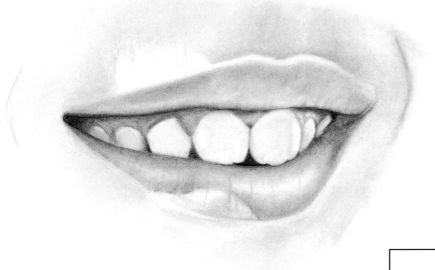

⑤ Adjust

Between the shiny white for the lips and the back corners, everything else is shaded. Ask yourself why you can see something—is it because the lip or gum is lighter or darker than something next to it?

More Smiles

BRACE YOURSELF
Maybe your teen doesn't appreciate his or her braces, but there's no reason to wait for them to come off to draw that face. Notice that braces are actually areas of light, shiny metal, which means you need to darken the teeth so that they will show.

PICKET FENCE
There is a stage in a child's life when the baby teeth fall out and the adult teeth emerge. At this time, the spaces between the teeth resemble a picket fence. You simply draw and darken them.

The Ears

Ears differ from face to face. The ear is about as long as the nose and runs approximately from the eyebrow to the tip of the nose. But these are only rough proportions—use the proportion of the ear you are viewing.

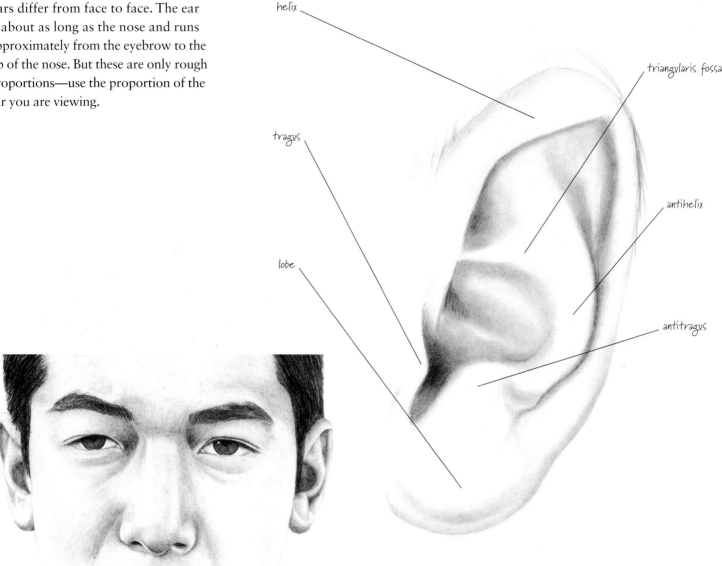

helix

triangularis fossa

tragus

antihelix

lobe

antitragus

Ear Shapes
Although ears vary from child to child, the basic shapes of the ears remain essentially the same as an adult's. Let's practice drawing an ear.

Parts of the Ear

Making Faces

Portraying a facial expression takes a drawing from mundane to delightful. You can do this by carefully observing and drawing minor details. Subtle details such as the lift of an eyebrow, the tug at the corner of the mouth, or the slight widening of the eyes are items that our weary brain needs to record. Of course, some children's expressions can-not exactly be classified as subtle.

Ear Placement

The back of the head tends to be rounded. We want to be sure the head shape is correct when we place the ears so they relate in location to the front and back of the head. Ears are not placed in a vacuum.

A common mistake artists make is to place the ear the correct distance from the front of the face, then cut off the back of the head, resulting in "flat-head syndrome."

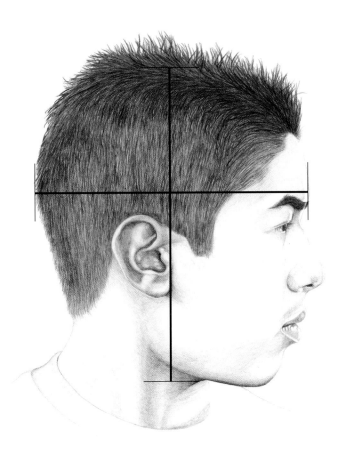

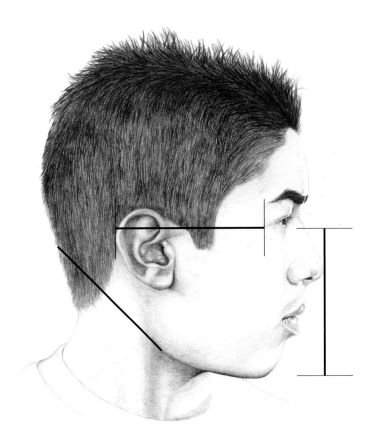

Measure to Avoid Flat-Head Syndrome
Draw a line from the top of the head to the chin, then a second line from the middle of the forehead to the back of the head. This measurement will help you avoid flat-head syndrome by giving you the correct size and curve of the back of the head.

Place the Ears
When children draw faces, they commonly line up the top of the ear near the eyebrow and the bottom of the ear at the bottom of the nose. In actuality, the distance from the back of the eye to the back of the ear is about the same as the distance from bottom of the eye to the bottom of the chin. (Babies' proportions are different, so just use this rule of thumb for children.) The ears have a similar angle to the jaw. That is, if you drew an imaginary line up the back of the jaw, it would have the same angle as the ears. The front of the ears are in front of the line of the jaw.

Drawing Ears

Ears are not very difficult to draw. Use the white plaster casts to become familiar with where you might expect to see lights and darks on a real face.

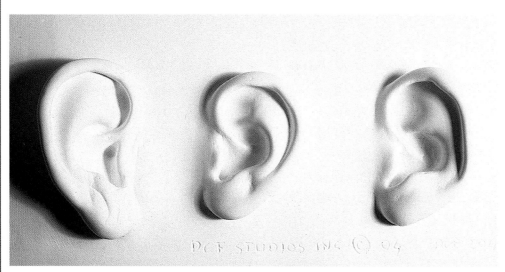

Shadows on the Ear
The plaster casts remove the worry of having to accurately represent skin tones and allow you to just concentrate on seeing the range of values (relative lights and darks) on the face. Unlike drawing the ears of your child, you don't "love" these ears, so you can be a bit more objective. OK, maybe you have formed an attachment to your child's ears . . . but you get my drift.

PLASTER CASTINGS COURTESY OF PHILIPPE FARAUT

❶ Draw Half a Heart

From the front of the face, the outside of the ear looks a bit like half a heart.

❷ Draw Another One

Starting below the original line, create the bottom of the helix. The helix folds itself into the lobe toward the bottom quarter of the ear.

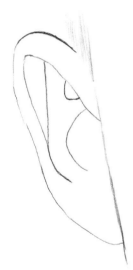

❸ Draw the Triangularis Fossa

Draw a shape roughly like a triangle, turned upside down and slightly melted.

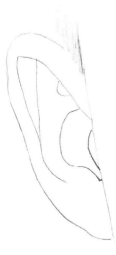

❹ Add the Bumps

Add both the tragus (pointing into the center of the ear) and the antitragus (pointing upward and often slightly forward).

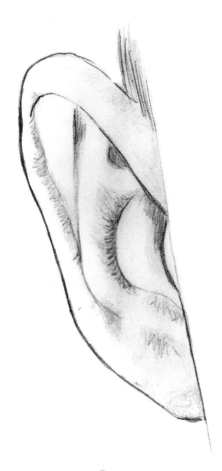

❺ Add Shading

Use the plaster casts as reference as you add shading to the ear. Use a B pencil to apply graphite to the paper, then blend using your paper stump. The top of the ear will be lighter, as will the center of the lobe. Squint at the ear casts to see the shading more clearly.

Special Note

Having trouble completing the steps? Cut a small opening in a piece of blank paper and use it to just look at one tiny part of the ear at a time.

The Hair

The items that seem to create the most difficulty, whether drawing an adult or child, are shading and hair. I find the biggest secret to drawing hair is that it takes time. You should plan to spend a lot of time on the hair because there really aren't any shortcuts.

Sharpen several pencils, because hair is fine (especially children's hair) and requires a sharp point.

- **Straight hair.** Even though the hair is "straight," make sure it conforms to the roundness of the head. Your pencil marks should follow the direction that the hair grows.
- **Curly hair.** Curls shouldn't just look like pencil squiggles. Each curl is made up of many hairs; therefore, many pencil strokes are required to make it look real.
- **Thick hair.** Where hair is thick, your pencil needs to make many, many lines to indicate this. A few lines smudged together just won't cut it.
- **Thin hair.** The secret to creating thin hair is to shade the head before adding hair so that the head shows through the hair.

Curly Hair
Curly hair takes a long time to draw. You will be "combing" each curl in the direction the hair grows. You will also want the hair to look fine and not like thick, dark pencil strokes.

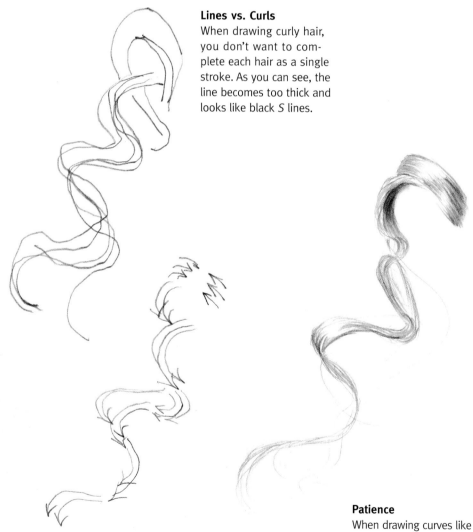

Lines vs. Curls
When drawing curly hair, you don't want to complete each hair as a single stroke. As you can see, the line becomes too thick and looks like black *S* lines.

Patience
When drawing curves like this, it will take several strokes to complete the curve to give it a hairlike appearance.

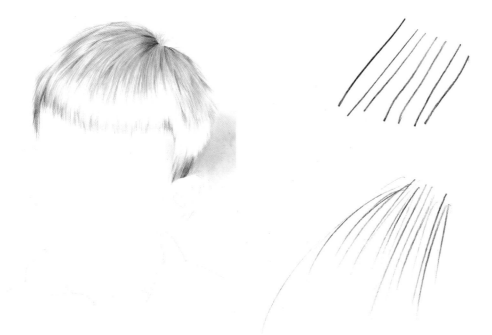

Psssssst!

There is no secret shortcut to drawing children's hair. Just remember to:

- *Have a lot of sharp pencils on hand.*
- *"Comb" the hair in the direction it grows.*
- *Be patient.*

Shine

Although you can erase a shine into hair, a far better way to create shiny hair is to leave it white.

Create Feathered Ends

Lift your pencil at the end of straight hair strokes to create "feathered" (that is, hairlike) ends.

Baby Hair

To depict the thin and fine hair of babies, simply shade the head before adding the hair.

105

Drawing Hair

Let's practice by creating the shiny set of bangs from page 105.

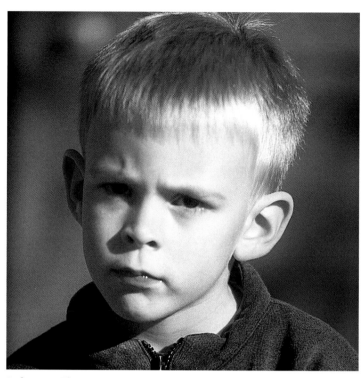

Reference Photo
Notice that the hair isn't flat on the head, but follows the curve of the head. The shine is white, so we want to preserve that as white paper. Keep your sketch light, because it's difficult to erase unnecessary lines.

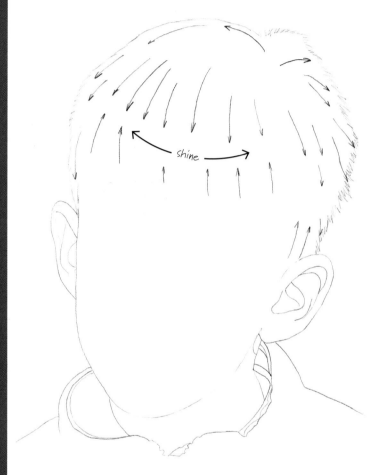

shine

① Identify Hair Direction

Decide on the direction that the hair is combed and the location of the shine.

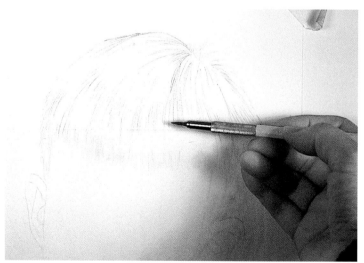

② Start Combing

Start combing the hair from the crown, lifting your pencil when you reach the area that will become the highlight.

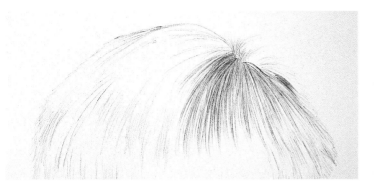

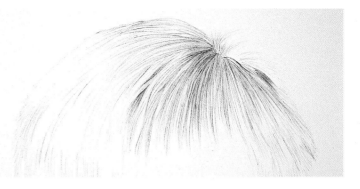

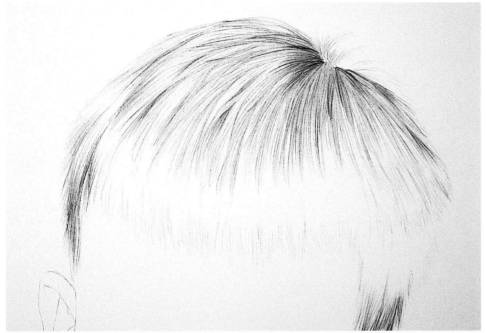

❸ Keep Going!

Keep your lines smooth and close together to create a combed look. If the hair is messy, your lines don't need to be as neat. "Bury" one side of the stroke. That is, make sure you can't see both ends of your line, or it will look like a loose hair floating across the head.

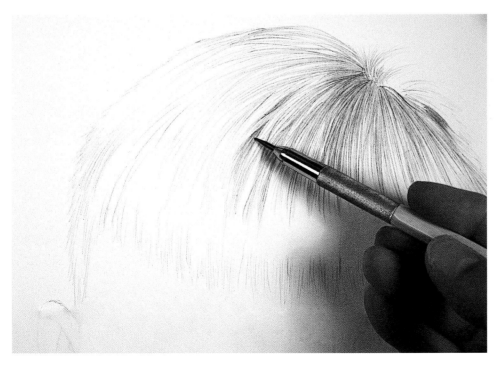

Create Depth as You Comb

Look for places where the hair crosses, forming two sides of a triangle. These areas may be darkened to create more depth in the hair.

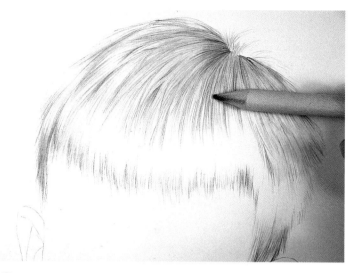

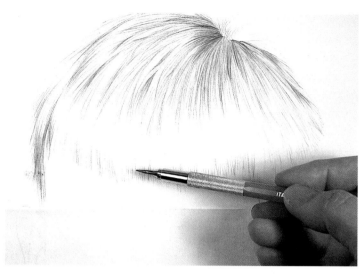

④ Blend

Fill in the white between the hairs to make the hair darker by smudging using a paper stump, chamois or cosmetic sponge. Be sure you don't lose the hair lines.

⑤ Reverse Direction

Reverse direction, creating the other side of the shiny area, and bring the feathered pencil stroke into the shine from the bottom.

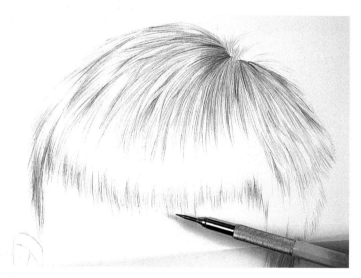

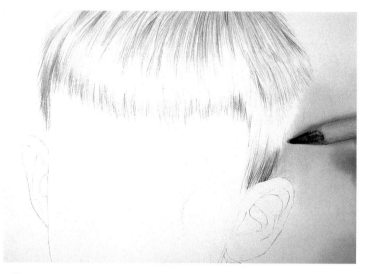

⑥ Reverse Direction Again

The ends of the hairs need to be softer, so bring the hair onto the forehead with yet another feathered stroke.

⑦ Darken the Background to Show Whitest Hairs

You can't make your drawing whiter than the white of the paper, so add a darker background to show white hairs. Hold the stump so that the tapered side is flat against the paper, not the tip. If you use the tip, you're putting too much pressure in too small an area, resulting in unattractive streaks. The darker the background, the more white the hairs look.

More Techniques for Creating Highlights

You learned to create the shine of bangs by leaving the shiny area white. But there's more than one way to create a highlight (though for large areas, it's generally better to use the white of the paper). You can also use a sharpened eraser to lift out hair, or you can get the exact highlight shape you want by creating a template from acetate.

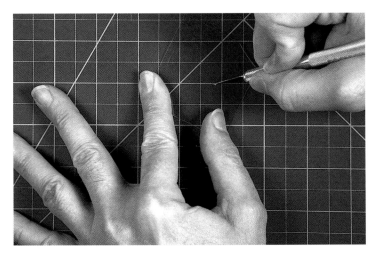

① Cut

Cut out the shape of the highlight from acetate with a craft knife. While you've got the craft knife and acetate out, cut more than one shape—fat hairs, thin hairs, straight hairs and curly hairs.

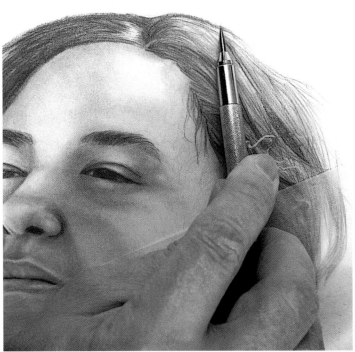

Creating Highlights and Dull Areas
This hair proved challenging because it had shiny areas as well as fuzzy hairs. To resolve the fuzzy-hair challenge, Rick used the side of his 6B pencil rather than the tip. This created less crisp, but smooth, defined hair.

② Erase

Place the acetate shape over the hair and erase through it. The template may be reused or used as a positive-shape template (a template where the cut out area forms a shape, such as a hair).

Sources of Acetate to Make a Template

- Clear thin report covers
- Transparency film for overhead projectors (the thick kind)
- Presentation sheet protectors

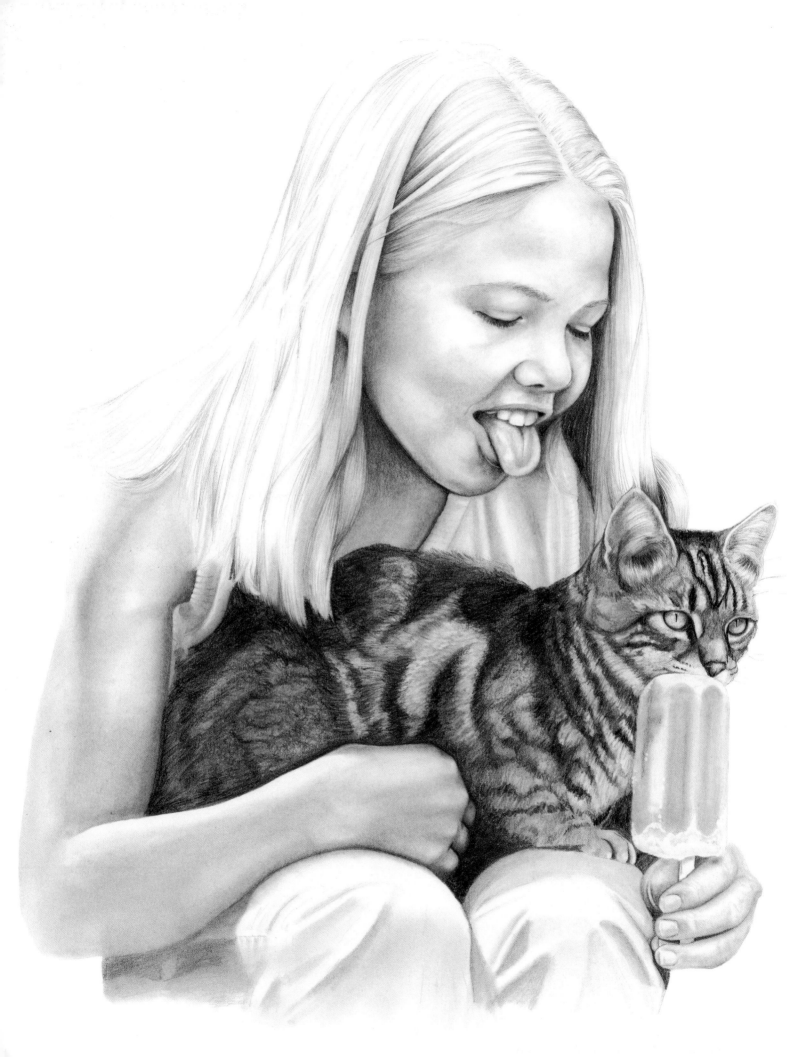

Smile for Grandma!

Up to this point, we've looked at different facial features, examining their shapes, how to shade them and how to proportion them on the face. We've also explored some rules of thumb for drawing in general. But that's just a start. Our drawings should be more than the just the rendering of accurate facial features on a correctly proportioned face. We want to show the personality; the essence of the child or grandchild. We want others to glimpse in our art the lovable, clownish, whimsical or impish nature that makes that particular child special.

In this chapter, we'll put it all together to create drawings of children that are more than portraits. As Rick and I worked through the various "major" drawings in this book, we photographed the steps we took in drawing. You'll see many applications of the different points we've made throughout the book.

Clothing

I confess: I like to draw faces, but I don't like drawing clothing. OK, I've said it. It's probably because my college instructors placed white sheets, artfully draped, on a table and told us to "draw!" Sheets are something you sleep on, not draw. Having said that, it's still something you need to learn to draw—clothing, that is, not sheets.

In all fairness, the white sheets taught us to see subtle shading while it was draped over various forms, giving shape to the form it draped. Let's look for a moment at what these white sheets can teach us.

Shading Sheets
Like the pattern found on the white shapes described in chapter three, fabric has a light-dark-light-dark pattern that gives it roundness.

Form and Texture
Clothing drapes on the child's body, giving form to the shapes underneath. Pay close attention to the direction of the folds of clothing.

Another factor to consider in drawing clothing is the texture of the material. The texture of wool differs from that of denim. Keep in mind that you can simplify a pattern found on clothing if you choose. Just because the fabric has teddy bears or small flowers on it, doesn't mean you have to draw it.

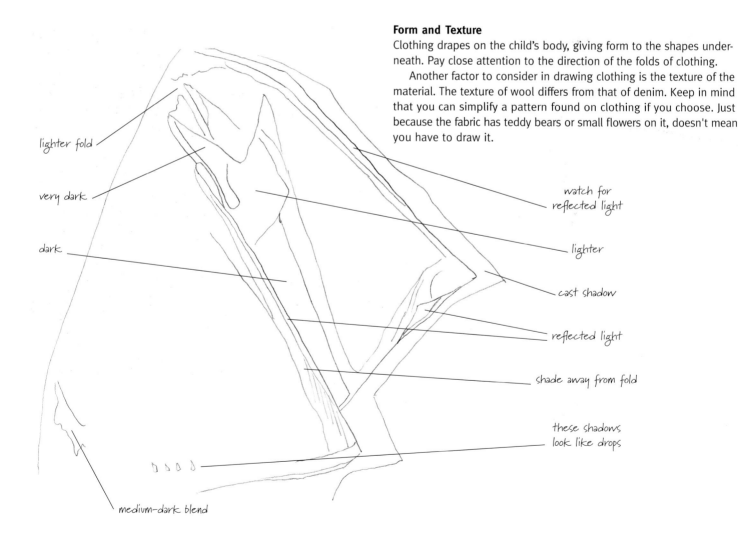

lighter fold

very dark

dark

medium-dark blend

watch for reflected light

lighter

cast shadow

reflected light

shade away from fold

these shadows look like drops

Using Props

You can draw any photo you already have, sketch from life or stage a photo you'd like to draw. In creating this book, we used a few photos sent to us by friends, but we snapped most of the photos ourselves. The older children were wonderful to work with, but there were some challenges with the young ones. One way to get a young child to relax is to have them interact with a prop—maybe hold their cat or dog, or smell the flowers in the garden. Here we share with you a few of our prop disasters.

Cole and Skylar Lindsey
This seemed like a good idea, but they look like they're behind bars.

Renee Ortega
The cat was fine for a bit, but grew tired of holding his smile. A people-friendly pet is the best choice for posing.

Cole Lindsey
Cole is watering a plant. Those are his fingers.

Shadows and Light

It took two rolls of film and a lot of screaming at my camera to come up with this photo. My nieces were either posing like deer in headlights or were a blur of activity. When I finally got the shot I wanted, the lighting was very dark. That meant that the area below Shilo's face was dark, as was her hair on one side.

When drawing a darker subject, the secret is to draw what you see. That is, if you don't see a detail, don't guess, just draw it as a dark shape. You can't be more "real" than the photo.

Reference Photo
Let's practice drawing the hair and face. Always check the proportions of your drawing before starting on the hair.

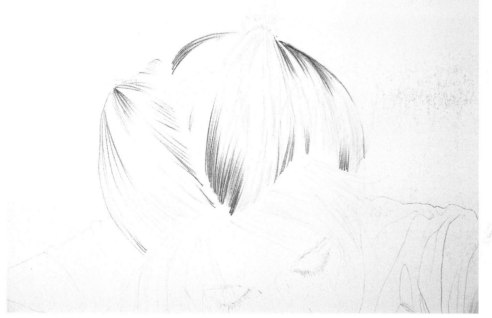

1 Establish the Direction of the Hair

Before I begin the hairs, I need to establish where the hair is going. I've drawn some lines to indicate the direction I'll be "combing" the hair.

Pssssst!

Sharpen several 6B lead pencils before you begin a drawing so that you don't have to stop.

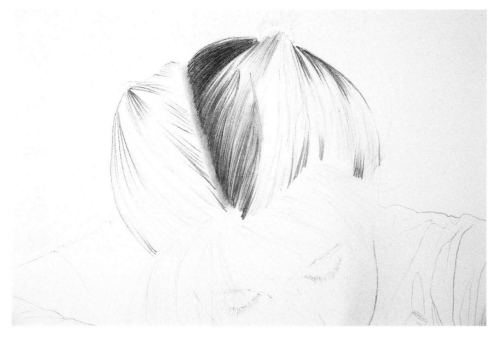

② Add the Darks

I like to see some darks as early in the drawing as possible. Because Shilo's hair is darker than her shirt, I've used it as a working value scale. (A value scale is where the lightest lights to darkest darks are laid out side by side.) Create a working value scale by placing a dark midtone in your drawing, and leaving another area white on your drawing. Now you can easily see the full range of shades you'll need to have to make an interesting drawing.

Although my drawing has gotten dark, my pencil is kept sharp. The shine of her hair is from leaving the lights, not from lifting them out.

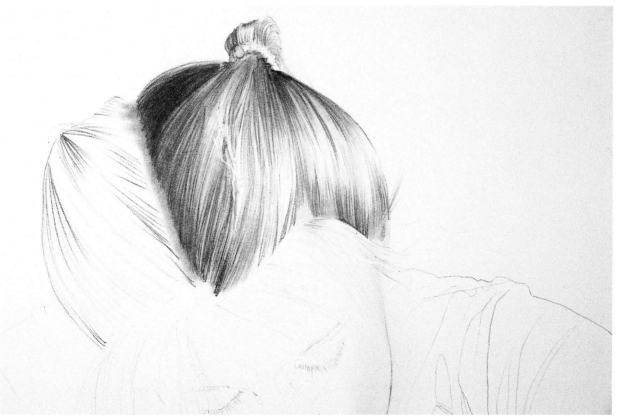

③ Blend the Darks

I've completed one side of Shilo's hair and blended the darks at the base. It's important that the lines remain lines and are not blended together—otherwise the hair will have a flat, decidedly "unhairlike" appearance.

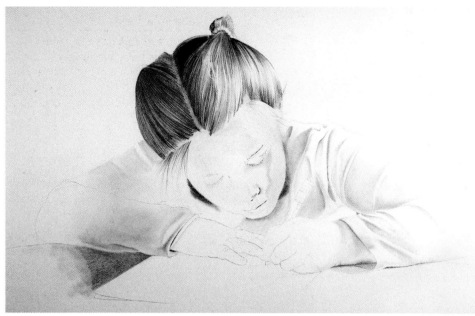

④ Shade Lightly

Lightly shade Shilo's face and clothing. On the original photo, there's a large dark area next to her face. Wait to smudge it later. If you were to work on this larger area, making it dark, you would have the potential of accidentally dragging some of the dark graphite into an area you want lighter. The drawing has a large range of values in it because of the darks in her hair. You want to have some lights, midtones and darks throughout the sketch.

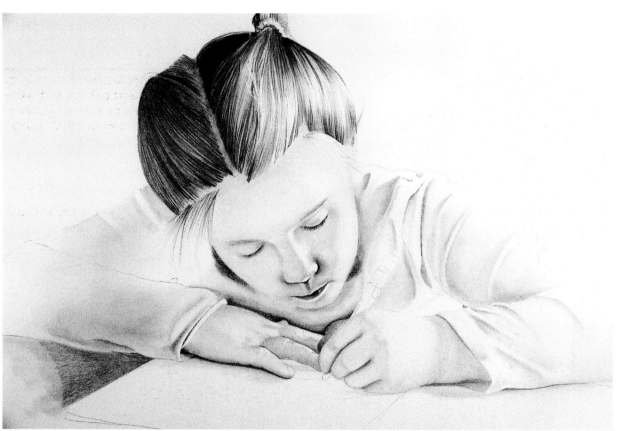

⑤ Work on the Entire Face

Shilo's face is taking form in an overall manner—that is, one facial feature is never completely finished before another.

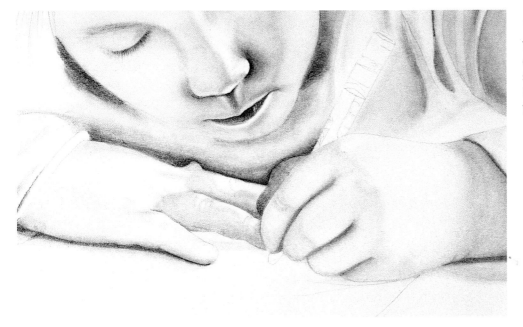

6 Draw the Hands

The lights and darks on the hands add dimension and make them believable. Hands should be no more difficult than faces. Use the same light-dark-light-dark pattern you've employed to create faces and fabric.

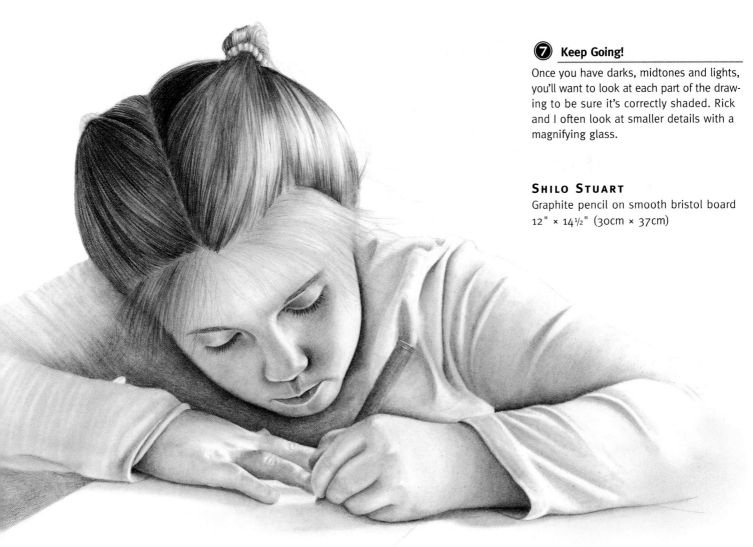

7 Keep Going!

Once you have darks, midtones and lights, you'll want to look at each part of the drawing to be sure it's correctly shaded. Rick and I often look at smaller details with a magnifying glass.

SHILO STUART
Graphite pencil on smooth bristol board
12" × 14½" (30cm × 37cm)

The Smallest Details

Cortney Lindsey is Rick's niece and a beautiful girl. Rick and I worked together to create this drawing. When we work together, Rick does the initial sketch, then passes the line drawing on to me. I place the working value scale (a full range of lights to darks) on the drawing and work on the hair. Then it goes back to Rick to refine the drawing. Here's what he did to make the drawing look more childlike.

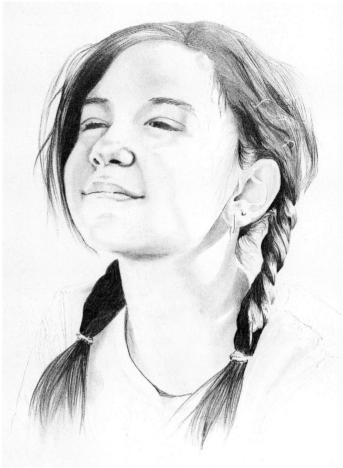

❶ Complete the Basic Drawing

Lay in the overall shading and hair. The remaining work is refinement.

❷ Refine the Eyebrows

Thicken Cortney's eyebrows, correct the shape and darken the drawing overall. It's common to avoid the eyebrows, but they can really make a difference in capturing a child's likeness.

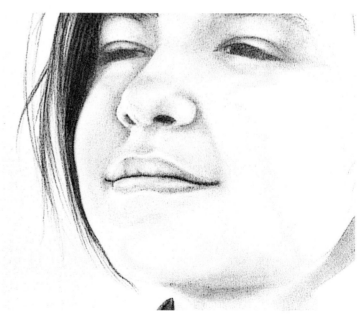

❸ Darken the Mouth

Although her mouth is correct in shape, it requires more darks. Further define and darken the nose and chin.

⑤ Soften Harsh Edges

Using gentle pencil strokes, paper stumps and a kneaded eraser, soften the harsh edges. With a kneaded eraser, lift out any areas that should be lighter.

④ Define the Ear and Create Wisps of Hair

Darken the ear to create shadows. Notice how the contrasting values make the drawing more interesting. Create the wisps of hair on her face using a sharp HB lead pencil. Keep defining and blending tones around the ear.

Create the wisps of hair on her face using a sharp HB lead pencil. Keep defining and blending tones around the ear.

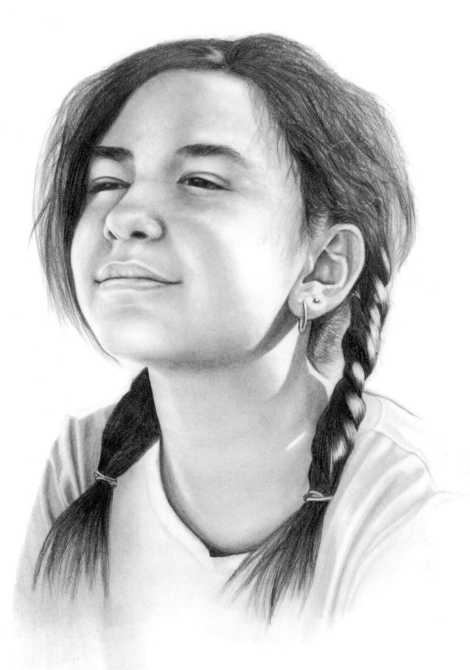

CORTNEY LINDSEY
Graphite on smooth bristol board
16½" × 11" (42cm × 36cm)

Capturing Character

Capturing Orion's expression was the goal of this drawing. The challenges were making sure it was an accurate depiction, not a caricature, and also finishing the top of his head that the photo didn't show.

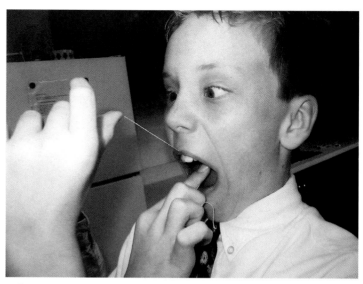

Reference Photo
Nadeoui Eden sent us this wonderful photo she took of Orion flossing his teeth. It made us laugh, and we loved it. We asked for permission from both Orion's parents and the photographer to use it in this book.

① Erase Any Unnecessary Lines

Before you begin to shade any drawing, all extra lines must be erased including guides, unneeded sketch marks and grids. It's difficult to remove them after the shading process begins.

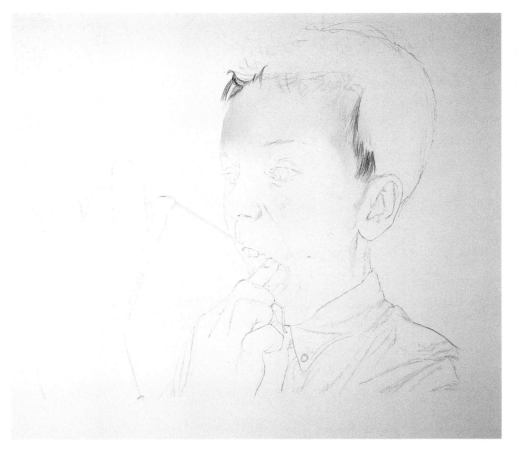

② Establish the Values

Start the hair and add shading to his forehead. It is good to establish some values (relative lights and darks) early on in the drawing.

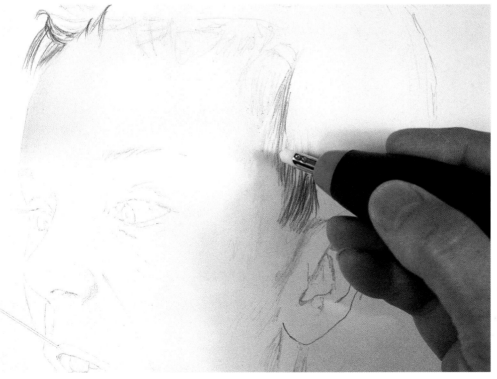

③ Lift Out Light Values

This subject has white hairs as well as dark. You can't "draw" white hairs, but you can lift them out of a darker background with your eraser.

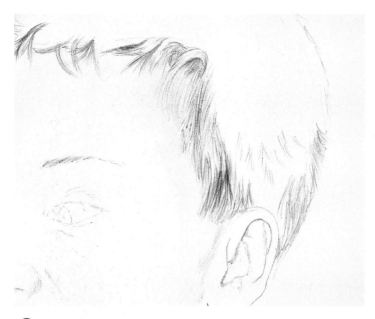

④ Randomize the Hair Strokes

Pencil strokes should be about as long as the length of the hair strands. Take care to keep the strokes random, rather than in rows, unless you're drawing a hair part in the scalp.

⑤ Continue Shading

Work your way down your subject, softening the shadows and shading. I don't begin in any particular formula—sometimes I start with the eyes, sometimes the hair, sometimes the nose. As long as your underlying drawing is correctly proportioned, you have the freedom to choose where you begin.

⑥ Hone the Drawing

Add an overall light shade to the entire face.

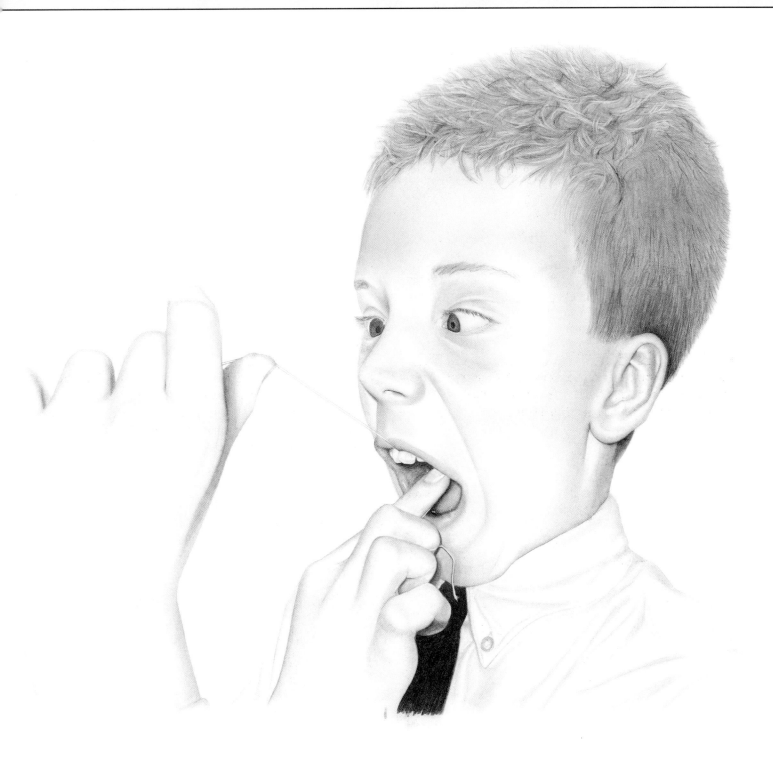

⑦ Add More Dark Areas

The darks in a drawing make it pop, but be sure they're in the right place before digging into that 6B lead! (It's horrible to erase.) Add some dark areas with a 6B lead pencil.

The drawing now has some of the subtle details that make it alive. For example, his teeth aren't just white—they have detail lights and darks that are visible in the photo.

Rick improved my finished drawing by straightening the hair and removing some of the highlights.

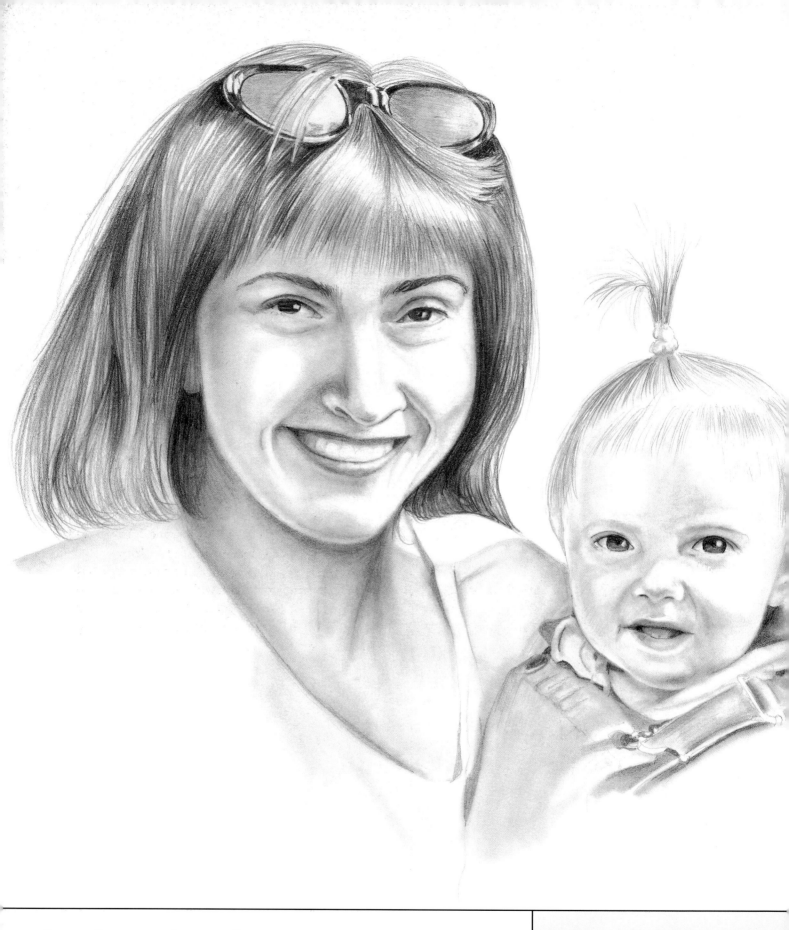

DIANA, SHILO AND AYNSLEE STUART
Graphite on smooth bristol board
14" × 17" (36cm × 43cm)

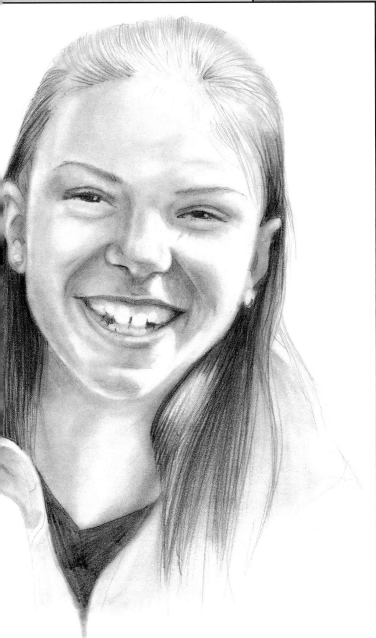

EMPTY NESTS

Secrets to Drawing Realistic Children is a start—a gentle nudge for you to take those first, tentative steps toward the joy of drawing your children or grandchildren. It's funny, but every time I finish teaching a class and send my students on their way, I feel like my flock has flown and I now have an empty nest. They are on their own and I'm no longer there to look over their shoulder and say, "ah, yes, that's better," or "you'll need to make that area darker." I feel, in the case of this book, that I want you to stay longer, to explore more drawings of children with me. After a year of photographing, sketching and drawing children, I've discovered so much more that I'd like to share.

I think a second book is possible, so with that thought in mind, I'd like to hear from you with your ideas and photos. Please contact me at carrie@stuartparks.com. In the meantime, don't sit too near the television, eat your vegetables, keep your pencils sharp, and God bless your artistic endeavors.

INDEX

The best in fine art instruction and inspiration is from North Light Books!

THE LITTLE BOOK OF DRAWING: A FRIENDLY APPROACH
by Mary McNaughton

This book is a friendly little reminder that anyone can draw and draw well. Dr. Mary McNaughton's unique, friendly approach will help you rediscover art and develop the creative voice within you. *The Little Book of Drawing* covers all fundamental concepts and techniques; provides engaging and challenging exercises; and helps you apply what you've learned to explore your own unique style with drawing projects ranging from gardens and landscapes to animals and the human figure.

ISBN-13: 978-1-58180-885-8
ISBN-10: 1-58180-885-2
hardcover, 144 pages, #Z0491

THE DRAWING BIBLE
by Craig Nelson

The Drawing Bible is the definitive drawing resource for all artists! Craig Nelson clearly explains basic drawing principles and shows you how to use a wide variety of drawing mediums, both black-and-white and color. Demonstrations and beautiful finished art throughout will instruct and inspire you, and the book's chunky size and spiral binding make it convenient to use and easy to carry anywhere.

ISBN-13: 978-1-58180-620-5
ISBN-10: 1-58180-620-5
hardcover, 304 pages, #33191

DRAWING & PAINTING PEOPLE: THE ESSENTIAL GUIDE
edited by Jeff Blocksidge and Mary Burzlaff

This is the very best instruction culled from North Light's most popular books on the subject, making it the definitive guide on drawing and painting people. Features a range of popular media, including colored pencil, oil and watercolor, and portrays subjects of various ages and ethnicities. This reference is loaded with straightforward, hands-on instruction that the novice can pick up to get started, while more advanced artists will find sound methods and expert tips for taking their work to the next level.

ISBN-13: 978-1-58180-981-7
ISBN-10: 1-58180-981-6
paperback, 192 pages, #Z0817

These books and other North Light titles are available at your local fine art retailer, bookstore or online supplier or visit our website at www.fwpublications.com.